THE BLACK COUNTRY

THE BLACK COUNTRY

EDWARD CHITHAM

AMBERLEY

First published 1972
This edition 2009
Amberley Publishing
Cirencester Road, Chalford,
Stroud, Gloucestershire, GL6 8PE

www.amberley-books.com

Copyright © Edward Chitham 2009

The right of Edward Chitham to be identified as the Author
of this work has been asserted in accordance with the
Copyrights, Designs and Patents Act 1988.

British Library Cataloguing in Publication Data.
A catalogue record for this book is available from the British Library.

ISBN 978 1 84868 452 2

Typesetting and origination by Amberley Publishing
Printed in Great Britain

CONTENTS

PREFACE

This new edition of *The Black Country* preserves most of the text of the 1972 printing, but brings it up to date in some vital respects. Now freed from the previous Longman Young Books format, it has been possible to give it a very different style. The Black Country has changed considerably in the interim, with many old landmarks gone and new ones erected. I have tried to maintain some of the flavour of the previous view of the area, which was thought highly successful. My aim has been to give a clear historical overview for the general reader, without too much scholarly complexity. This edition is illustrated in a totally different way from the former, and it is hoped the public will find this format attractive. Interest in the field of local history has never been greater, and I hope this new edition will lead members of the public to delve more deeply into the heritage of their own local village or town.

SOURCES OF ILLUSTRATIONS

Figures 5, 6, 7, 9, 10, 11, 16, 17, 22, 27, 28, 29, 31, 34, 41, 46, 48, 50, 52, 53, 54, 55, 57, 59, 60, 61, 62, 63, 64, 67 and 68 are the author's own photographs.

Figures 14 and 37 are from Nash's *Worcestershire* and figures 24 and 25 are from the author's copy of Shenstone's poems; figures 40 and 42 are from the original edition of *The Old Curiosity Shop*.

Figures 4, 8, 12, 13, 15, 21, 23, 32, 33 and 49 are from early twentieth-century books and pamphlets in the author's possession.

Figure 65 is from a Guy Motors promotional book.

Figure 66 was first published in *The Eagle* magazine.

Figures 36 and 38 are from *One Hundred Years of Lockmaking* issued in 1982 by H. Hough and Sons, with the text by Geoffrey Allman.

Figure 3 is from a nineteenth-century map of Dudley; figures 26 and 51 are from old commercial postcards.

Other illustrations are from the author's collection, origins so far undiscovered. Every effort has been made to trace any copyright which may inadvertently have been infringed. If such can be discovered, full acknowledgement will be made in any future edition.

A GREEN BEGINNING

When Satan stood on Brierley Hill
And far around he gazed,
He said "I never shall again
At Hell's flames be amazed."

This is how many people think of the Black Country today. Until recently they would have been right to look for scorching fires, signs of desolation, dark canals, spoil banks and grimy buildings. But the Black Country is, and always was, a district of contrasts, where old customs die hard and folklore lingers among tower flats and bingo halls. An Elizabethan mansion rises from between rows of Victorian workers' houses; a medieval castle surrounded by woods looks down on pre-war council housing, narrow-boats moored along the local "cut", and a brand new shopping centre. The Black Country is built up, almost from end to end; yet in some strange way it is still "country" not "town", a group of villages of various sizes. In each of these everyone knows everyone else, but beyond the borders you're a foreigner.

 If you take an observant ride through any section of the area, you can see history mingling with modernity. The journey from Birmingham to Dudley will serve as an example. The most direct route between the two towns follows the eighteenth-century turnpike road, and the modern red bus which travels it is successor to many forms of transport. You could, until lately, still see along the route signs of the trams, which last ran in 1939. This is still Route 87, though no longer running on rails.

 Two miles from the centre of Birmingham the bus crosses a brook (invisible, since it is culverted below the road) and passes from Warwickshire to Worcestershire at the boundary of the Metropolitan Borough of Sandwell. This brook was a county boundary before the Norman conquest. Since then it has divided Birmingham parish (Warwickshire) from Smethwick (until 1966 in Staffordshire). To a nineteenth-century traveller, riding in a shaky coach through these desolate parts, it might

well have been an important landmark on his journey, but now we hardly notice it as the bus sweeps across the boundary and up Cape Hill towards the centre of Smethwick.

Two relics stand beside the road on our right hand side, monuments to previous forms of local government. The first is Cape "board school" (the Black Country abounds with "board schools") on which is a plaque, with appropriate statuary, assigning the school to "Harborne School Board", an organization now lost in limbo. The second is Smethwick Council House, the seat of government for the area until 1966, when Warley Borough Council came into existence. This too, passed in turn. These two buildings have parallels all over the Black Country; the place is littered with discarded monuments of local government. It seems as though no one has ever been able to sort out local anomalies, though intrepid governments have often tried.

The Black Country was never tidily in one county until 1972. One hundred and seventy years ago the coach traveller would have passed through four on his way from Birmingham to Dudley, and until 1972 the modern red bus still passed through three county boroughs. One of these boroughs, Dudley, now includes areas from three counties: Sedgley and Kingswinford in Staffordshire, Stourbridge and Netherton in Worcestershire, and Halesowen once in Shropshire.

Not much further along the road from Birmingham to Dudley, the bus passes a complex interchange of transport facilities which is almost a transport history in itself. Within an area covered by a square half mile can be found two canals, two railways, the old turnpike road and the new M5, a toll house and a modern flyover. Roebuck Lane bridge, a splendid metal bridge, takes the lane across the great main railway line from London to Liverpool, with its frequent electric services to the capital, then over the new canal cut, which stretches in a deep gorge towards the centre of Smethwick; then the lane crosses the earlier lines of the Birmingham-Wolverhampton canal, begun in the late 1760s. Side by side with the road bridge, another railway bridge crosses the electric line. This was the Great Western line from Snow Hill to Kidderminster, and the bridge is a last echo of the splendid tussle between railway companies for the lucrative Black Country trade.

Transport has been important in the Black Country, and new forms of transport are continually being found. But the Black Country never completely discards the past, preferring to "codge" the past to fit present needs. So the canals are being adapted to new uses, and instead of the coal boats of the nineteenth century you are likely to see cabin cruisers or converted butties moving along, making for open country. It was the canals that brought the district its first upsurge of prosperity at the end of

the eighteenth century and, ever since, the canals have remained a feature of the Black Country landscape. They appear in the most unexpected places – over, under and alongside the roads – providing an interesting contrast in an area where there are no large rivers.

As the red bus proceeds on its way to Dudley, the houses become more spaced out. Some may look grimy and dusty, but behind them is the relic of a field, and the road is bounded by a brightly sprouting hawthorn hedge. Here, beyond Oldbury, is the real heart of the Black Country, the land of those mysterious folk characters Enoch and Eli, stories of whom are legion, and still growing in length and number.

For example, it is said that one day Enoch was walking towards the colliery where he worked when he met Eli coming in the other direction.

"Where'm yo a-gooin' this mornin', Eli?" he asked.

"Gooin' to werk, o'course," Eli replied.

"Well, yo'm a-gooin' the wrung road, bay yer?"

"Oh, ar. So I bin. I terned round to light me pipe, and I'n forgot to tern back again."

Was Eli really "saft in the head" as Staffordshire folk are supposed to be, or was he being rather canny? In countless Black Country stories the characters laugh at themselves, but with a knowing wink, as if to say the fool is sometimes wiser than the clever man.

If we now return to our bus journey, we find ourselves climbing steeply towards Dudley. On the right the ground falls away in the direction of Tipton and Great Bridge, while on the left we are nearing a range of hills, the side extended by quarry tips, but the crest still crowned by a wind-swept clump of trees. As the bus arrives in Dudley bus station, we have reached the watershed of England which runs through the Black Country. The streams to the south and west flow into the Severn, and thus into the Bristol Channel, while the streams to the north and east flow down to the Trent and thus out to the North Sea. The Black Country stands high, and was once desolate, until the discovery here of coal and other minerals made settlement attractive. As we shall see, early inhabitants were few and far between; yet all this changed from the eighteenth century onwards, when King Coal made Black Country fortunes.

Defining the area of the Black Country has always been difficult. At one time it was generally regarded as starting at the next village or town to the one you lived in yourself. If, for example, you lived in Stourbridge, then you regarded the Lye as the start of the Black Country; but if you lived at the Lye, then the Black Country 'proper' started at Cradley. Nowadays, though, people have begun to be proud to be associated with an area where so much inventive and productive labour has taken place and where eccentric folks can be called "Black Country characters" instead of

being dismissed as unconventional. No one would call the Black Country beautiful in a traditional way, but it has that dash of salt often lacking from our daily life these days; it straddles several centuries and is not entirely at home in the twenty-first.

Perhaps if we take coal as a main factor in Black Country life we can arrive at a working definition of the area. The South Staffordshire coalfield stretches from Walsall and Bloxwich in the north down through Bilston, Darlaston and Wednesbury to Dudley at its centre. On the east and west lie West Bromwich and Sedgley respectively. On the south the coalfield stretches through Brierley Hill to Amblecote, the Lye and Cradley, and round in an arc from Halesowen through Old Hill to Rowley, Oldbury and Tipton. Add to these towns places where coal was marketed and used, together with parishes where the overspill population now lives, and you have some idea of the boundaries. Little coal is gathered in the Black Country nowadays, but its influence is strong everywhere, from Stourbridge to Wolverhampton, from Himley to West Bromwich.

Coal, however, is only one of the minerals which has caused the Black Country to be riddled with mines and quarries. Ironstone, fireclay, sand of various kinds, limestone, and dolerite or "Rowley Rag" have all been excavated by the burrowing men of the Midlands. Many of these minerals are still being brought to the surface in vast quantities, notably the hard granite-like dolerite, which is used for road surfacing all over the country. High up on Turner's Hill is a vast cavity, so great that when you look down from the lane that runs by it, the quarrymen seem like gnomes. Kestrels nest on the ledges at the sides of the cavity and hover at the level of the lane, watching mice or frogs on the floor of the quarry hundreds of feet below. The quarrymen blast deeper into the huge hollow, till one wonders if there will be any Turner's Hill left in a few years. Such work as that of the miner and quarryman breeds independence, and the Black Country man is pleased to be "a law unto himself".

Apart from the trades associated directly with raw materials, many other industries have bred this independence. Iron founders, for example, were men of prodigious physique, who drank beer by the gallon and cared for nobody. The nailers and chainmakers were craftsmen who worked in or near their own homes in small shops where pride in the job mattered. Locksmiths, bitmakers, saddlers and enamellers all worked in cottage industries, where the small units helped to break down class differences and the "gaffer" often worked beside you in the same shop. There were plenty of hard times and industrial disputes in the nineteenth century, but the working class bitterness apparent in other parts of the country was never quite repeated in the West Midlands. Many times the miners cursed the iron, coal, limestone and clay; many times the nailers cursed the locally

made nail-rod; but these were their living when cotton-spinners starved; and when the farmer's crops failed there was always a horde of minerals to be dragged to the surface, providing the means to carry on life through even the worst economic storms.

Who the earliest inhabitants of the Black Country were, we just do not know. The population was certainly very sparse when the Romans forged up through the Midlands in AD 47-48, and they met no resistance. Traces of their occupation today are very small, though you can find Roman roads still used by modern traffic not far away from the Black Country. There must have been at least two tracks through the centre of the area, one leading from the marching camp at Metchley, near Edgbaston, to Penkridge, and the other from Penkridge through Greensforge camp near the Smestow Brook, down towards Droitwich.

It may be that we shall discover more about these Roman tracks than we know at the moment. Careful study of old maps and minute observation of the area on foot may bring to light evidence that is still hidden. The road from Metchley to Penkridge must have run through Oldbury, and probably Tipton and Wolverhampton. But all these places were so ruthlessly pillaged during the nineteenth-century search for minerals, and are being so rapidly built up in the search for building land now, that the only clear traces of Roman times are to be found on pre-industrial maps.

Metchley fort itself is again being built over, but an emergency dig revealed wooden footings for buildings, ways between the buildings, and a quantity of pottery and other fragments. There was no time to finish off the exploration before builders moved in to put up extensions to the Queen Elizabeth Hospital. In a strange way this building is in itself a monument to the Romans, who brought to our country a knowledge of anatomy and medicine which was a tremendous advance on anything Bronze and Iron Age man knew.

Among the other minute clues to the story of Roman occupation in the Black Country is the legend of three finds, two of which came to light in the Napoleonic age. At Rowley Regis, a boy was watching while a great piece of ragstone was moved to repair a wall. It had lain there age upon age, as a foundation for one of the stone walls which could still be seen in the 1970s snaking over the Rowley hills. The stone shifted, revealing something lying amidst the rubble beneath. It was an earthenware pot, cracked with time, and lying beside it was a dull metallic disc which on polishing turned out to be a Roman coin. More coins spilled out of the pot, which was taken to the house of the landowner, the Rev Cartwright, who counted the coins and found that there were 1,200 of them, representing most of the Roman emperors. The story of the find became a legend and was still remembered in the village forty years afterwards. But the coins

themselves disappeared and were doubtless sold by Rev Cartwright. Who had buried them, far off in the dim past? Was it the same man who buried a small hoard at Cakemore, or a scattering at Hurst Hill, Sedgley? Do these three coin finds perhaps provide information which could be used to locate the Roman tracks?

When Roman influence in Britain died down, the way was left open for the Anglo-Saxons. These men began by pillaging the land, but eventually settled it. They were the first people to clear the jungle from what was one day to become the Black Country. Their chief memorial is not in buildings, but in place names. In those pioneering days when small bands of Saxons first climbed up from the valleys of the Severn and Trent there were few names in use. But as the invaders cut down trees to make clearings for their homesteads, they gave the new settlements names. From these names we can build up a picture of what the terrain looked like when they arrived.

The work of the later Anglo-Saxons was akin to that of the American settlers moving west, and we can imagine these wandering groups of invaders following either a primitive track or a small brook to a place where good drainage and clear springs gave them hope of a settled life. Here they staked out their claim as a family or group, chopped down trees and built their elementary stockade to keep out the rest of the world. Isolated settlements like this were sometimes called "tons", and there are many reminders of these in the Black Country in names such as Darlaston, Bilston, Netherton, Tipton and Wolverhampton. The clearings on hill slopes which they made and used for pasture were called in their language by the name "leah"; and from these we get the last syllable of such names as Dudley, Himley, Warley and Cradley.

It is a mistake to think that the Anglo-Saxons killed all the Celts or drove them into Wales. They certainly ejected them from their property and killed the menfolk. Even so, names like Walton ("foreigners' settlement") indicate that the Celts survived in isolated places. No doubt there were Saxons who

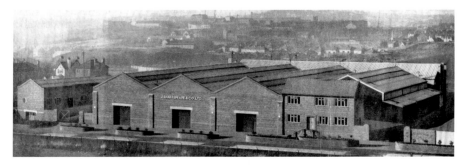

1. The Black Country: Old Hill and Netherton

married Celtic wives, and the inhabitants of Britain after the Anglo-Saxon conquest would be racially half Saxon and half Celt. The Celtic language disappeared, except in a few place names such as Kinver and Pencricket Lane, Blackheath. But the Celts themselves were not completely wiped out. If the name is anything to go by Walsall (the same first element as Walton) should contain a fair number of these "foreigners".

The Anglo-Saxons brought strange gods with them. Woden was regarded as the father of the race. He was a powerful god whose milieu was the wild hillside. He made great monuments, and hunted across the hills with a pack of baying hounds. Even in the seventeenth century these hounds could be heard in Wednesbury, the old miners said. The names Wednesbury and Wednesfield preserve Woden's name, and must indicate a local cult of this god. These Saxon gods displaced Romano-British Christianity, which had itself supplanted an earlier pagan religion no traces of which remain, despite persistent legends that the Druids practised their rites on Barr Beacon.

In time the Anglo-Saxons became Christian, and St Chad's diocese became established at Lichfield. St Chad's rule ran through what would one day become the Black Country, but which was still partly wood, partly moor, and all of it very thinly populated. Natural features formed the boundaries, as can be seen by reference to early charters. In particular, brooks could be counted to remain permanently in their place, and were often used to mark parish bounds. One famous incident happened on the borders of St Chad's diocese in the early eighth century. This was the martydom of St Kenelm, which took place near Romsley on the Clent Hills. Today St Kenelm is commemorated by a rash of Kenelm Avenues and St Kenelm Roads, but he is otherwise little known. There is a story, however, which exists in a number of sources, including Chaucer.

Kenelm was a boy prince, brother of Quendreda. When their father died the boy was put under the guardianship of one Askobert, an unsavoury character by all accounts. One day, Kenelm woke from a puzzling and terrifying dream, which he took to his nurse for interpretation. He had dreamed about a great tree, spreading kindly branches to shade the people. He himself was in the top of the tree, gazing down, when suddenly a crowd of men ran towards it and began to chop it down. Gradually the tree fell, and as it did so Kenelm found himself growing wings and taking flight into the air straight in the direction of heaven. The nurse looked worried, for a rumour had reached her which she dared not disclose, that Quendreda was plotting against his brother and intended to kill him on a hunting expedition. The nurse told Kenelm as much as she felt able, warning him not to go hunting. Nevertheless he went, and when he had wandered far away into Cowbach on the green hills of Clent, Askobert

ran up to him and struck him with a sword, felling him like the tree in his dream. Kenelm had only time to prophesise that good would come of these events when death overcame him. At this a white dove, which no one had noticed before, flew up from his body straight to Rome with the story of what had happened.

The Pope sent messengers to examine the case; they found on arrival at the spot that a hawthorn had sprung up where St Kenelm was buried. Nearby a spring of clear healing water flowed out and trickled down the grassy hillside towards the River Stour. A shrine was built on the hillside, and in later years a small church was founded near the shrine. To this day it is a pretty spot, unspoiled despite its closeness to the great industrial conurbation. In time it became a great place of pilgrimage, and remained so, under the patronage of Halesowen Abbey until the abbey was closed.

The exploration and settlement of England was interrupted by invading Norsemen, who at first drove the Anglo-Saxons before them. Later, under King Alfred, the Anglo-Saxons fought back. The Norsemen were then forced to retreat to the eastern part of England, called the Danelaw because there the law of the Danes or Norsemen replaced that of the English. The Black Country was English territory, and there are no recognizable Danish settlements in the area. We know of one important battle in the struggle to repel the Danes which took place near Wolverhampton, either at Tettenhall or Wednesfield, in 910; and it was after this that they retreated to the other side of Watling Street.

In those dim and distant days there was nothing to show that Wolverhampton would one day be the largest town in the West Midlands outside Birmingham. In the tenth century it was "the High Settlement (Hean-tun)", a small colony that bestrode the ridge with the valley around Dunstall on one side and Compton on the other. At this time there emerged the legendary figure of Wulfrun, whose name today distinguishes the town from North- and South-Hamptons. In 994 she gave a grant of land to a new monastery in Wolverhampton to enable some priests to propagate the gospel there. The boundaries of land given in the charter show that Wulfrun held land over a wide area in South Staffordshire including Bilston, Wednesfield, Pelsall and Featherstone. She must have been an influential woman, and was famed for her piety right down to the seventeenth century when she is mentioned by Michael Drayton, the Warwickshire poet.

Through her generosity a church was built at Hampton before the Norman Conquest amidst the rough houses of the village, on the site of the present St Peter's collegiate church. It is not difficult to see how commanding the position was if we look up Darlington Street towards Queen Square today. Wulfrun's was a rich endowment, and started

Wolverhampton on the road to its present prominence. But the only remaining physical monument which Wulfrun is likely to have seen is the Saxon High Cross in the churchyard. We may imagine that as she arrived to view the progress of her monastery, she might have stood by the old cross and reflected upon its age and its appropriateness as the symbol of the gospel in her town. Little would she have thought that it might still be there in a much changed Wolverhampton a thousand years later, smoke-begrimed but still recognizable.

When King William's men came riding to survey the land in the eleventh century for the great Domesday Book, they found South Staffordshire still untamed and thinly populated. The King himself held a good deal of it. Cannock Chase was a royal forest and there was a vast tract of land stretching through Pensnett and Kingswinford to Kinver where the King had hunting rights. He also owned parts of Bloxwich, Willenhall, Bilston and Tettenhall. Probably the most populous place held by the King was Wednesbury, where an estimated ninety-six people lived (compared with thirty-two in Birmingham and forty-six at West Bromwich). These were all earning a poor living in agriculture, scratching what living they could from indifferent land cleared from the forest. There is no mention of minerals in Domesday Book, and the great wealth hidden below the Black Country lay undisturbed.

We cannot be certain where King William's men stayed when they visited this area. There is one likely place, however. A high mott and bailey castle had been built at Dudley since the invasion twenty years previously. It is quite probable that this is where they stayed, and were entertained by His Majesty's loyal supporter, William Fitz Ansculf. He was a Picard by race, whose father had been rewarded for his services during the conquest by a barony stretching through much of the Midlands, and also covering areas

2. Domesday entry for Wednesbury and Bloxwich

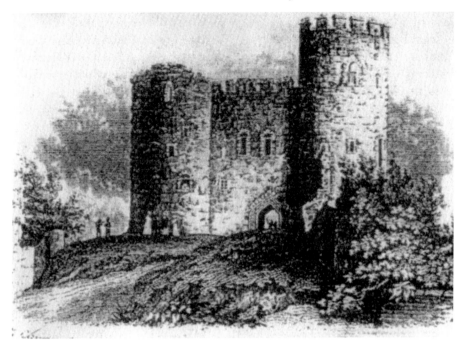

3. Dudley Castle

as far afield as Buckinghamshire. Not that the barony represented a solid block of land; King William was too wise to entrust whole areas to his beloved servants, in case revolution should arise there.

Nevertheless, if William Fitz Ansculf went up to the highest point in his castle and looked around he could see many of his manors. On a clear day, if you climb the castle keep (though that was not built in William's day) you can still see what a marvellous centre Dudley was for the seat of a Norman baron. You can see, as Fitz Ansculf saw, all his land at Sedgley along the ridge, at Penn, Ettingshall and Bradley to the north, and to Warley and Birmingham in the east, which were also parts of William's estate. You can still see the hills and dales, small streams and remnants of woods: but it is difficult to think away all the industry and the town streets and visualize the land as the baron saw it.

Domesday Book is a splendid record of the face of England in the late eleventh century. It tells us more about the country than we can discover again for centuries. But it is a complicated document, by no means always clear, and often needing skilled interpretation. Figures for population, for example, are not to be taken directly from it. There are unusual terms such as hide, virgate, plough-team, which have caused much disagreement among experts. Despite all this, most English people with a sense of the

past like to refer the history of their town or village to it, and feel there is something missing if they are not "recorded in Domesday". The Black Country towns and villages are no exception. There is undoubtedly a thrill in seeing one's own place mentioned in a document so old, which probably uses archaic spellings and talks about watermills or plough-teams when we have never seen any water other than a muddy canal at that point, and the only team we associate with the town is a football team.

It may give the flavour of the document if we detail a list of lands held by Wulfrun's "Canonicide Hantone" in the Wolverhampton area. Here is an English translation of this portion; the original was, of course, in Latin.

"The Canons of HANTONE [Wolverhampton] hold one hide of Sansone [the King's chaplain]. There is land for three plough-teams. In King Edward's time there were eight ploughs there. Now there are ten and thirteen serfs and six villeins and thirty bordars with nine ploughs. There are two acres of meadow.

"In BISCOPESBERIE [Bushbury] these same canons have one virgate of land. There is land for half a plough-team. There is one free man with one plough. It is worth twelve pence. "In TOTENHALE [Tettenhall] they have one hide. There is land for two and a half plough-teams, and there are three ploughs with one villein and three bordars.

"... The priests of Tettenhall have one hide in BILREBROCH [Bilbrook]. There are two freemen with one villein and two borders, who have two and a half plough-teams.

"The same canons have five hides in WODNESFELDE' [Wednesfield]. There is land for three plough-teams. There are six villeins and six bordars with six ploughs.

"The same canons have two hides in WINENHALE [Willenhall]. There is land for one plough-team. There are three villeins and five bordars with three ploughs.

"The same hold half a hide in PELESHALE [Pelsall]. There is land for one plough. This is waste.'

THE MIDDLE AGES

In some ways, England in the Middle Ages was like any underdeveloped country today. Villagers were poor, their homes primitive, their food scarce, and their lives short. The men who ruled them were harsh and remote; outside the village bounds stalked wild animals, while deadly diseases could carry them off in the twinkling of an eye. No wonder, with all these dangers threatening, that they turned eagerly to the consolations of religion, flocking in thousands to the shrines of saints like St Kenelm, and regarding the clergy as their one bastion against the fierce power of the King and the nobles. Too often, unfortunately, the clergy themselves were rapacious and quarrelsome.

But despite all this, progress towards civilization was made, even in such a backward and unpromising area as the Black Country. Steadily, tracks were hollowed out from town to town, forming the basis of the road system we still have. Toll gates were set up, markets established, schools inaugurated. Today we can look at the marvellous hall at West Bromwich Manor and wonder at the ingenuity of the thirteenth-century builders, who were determined to provide a large roofed-over space for banqueting and merrymaking. The dark oak beams soar to the sky, and it is easy to slip into the past and hear the sounds of shawm and viol. Other substantial medieval remains can be seen at Dudley Castle, Dudley Priory, Halesowen Abbey and in numerous Black Country churches. Each of these, with the small settlement that surrounded it, represented an island in the area of untamed scrub-land.

Most of the West Midland villages were small, several hamlets making up one parish. The open field system, with its traditional three fields in which one was left arable each year, was often modified here. Instead of the lush soils of the East Midlands and the Home Counties, the West Midlands possessed thin, unproductive soil. Often there was no room for more than one open field, and it was not surprising if men's thoughts turned very early to non-agricultural ways of earning a living. Limestone, coal, marl and ironstone: all held out promise to the peasants who could not scrape enough sustenance from their meagre fields.

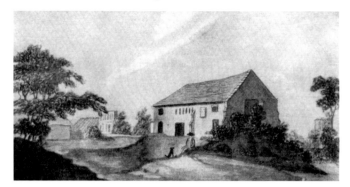

4. The Infirmary,
Halesowen Abbey

5. Dudley Priory

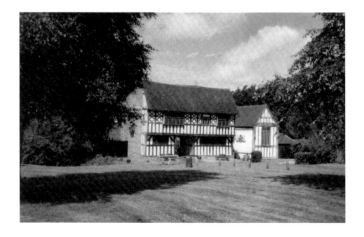

6. West Bromwich
Manor Gatehouse

All round the village settlements stretched the forest. This was not the dark forest of Germanic folklore. Parts of it were indeed thickly wooded, as is shown by place names such as Gornal Wood, Dudley Wood and Walsall Wood; but parts consisted of a wilderness of broom and gorse, coppiced trees, heath and moorland. Most of the forest belonged directly to the King, though some was owned by the Lords of Dudley and other great men. They had rights over the forest which amounted to a stranglehold, and could hunt wild animals there when they chose. The evidence of place names shows that there were deer, foxes and rabbits in abundance, and partly-tamed herds of pigs guzzling the acorns and beech mast. It is not recorded that the kings of England came to Pensnett to hunt the animals, though they did travel the country frequently for other purposes, and may have stopped here to do so.

Amidst all this "forest" of wasteland lived the delvers, smiths and charcoal burners, a shy people, no more inclined to stand the world's gaze than the foxes and deer. Doubtless at some time in the past their ancestors had tried to keep themselves alive on the produce of scattered strips in the open fields, but had been forced by bad harvests to take up alternative occupations that foreshadowed manufacturing industries. The delvers hollowed out quarries such as some of those at Wren's Nest and Castle Hill in Dudley, and the Arboretum lake in Walsall. They began to bring up "pit-cole" in the thirteenth and fourteenth centuries – for example at Sedgley in 1272, Kingswinford in 1291 and Wednesbury in 1345. Itinerant charcoal burners and smiths set up temporary settlements throughout the woodlands, cutting down the oaks and beeches, and using the resultant charcoal as a fuel for smelting the locally produced iron.

But as yet there was no power, either financial or political, in the hands of those engaged in primitive industry. All the influence in the land rested either with the temporal lords, represented locally by the Lords of Dudley and by stewards acting directly for the King, or with the Church, represented here by monastic establishments at Dudley, Halesowen, Sandwell and other smaller monasteries, and by the parish churches in market towns such as Walsall and Wolverhampton.

It is easy to see why the monks from Wenlock in Shropshire chose the site for Dudley Priory. It must have been a pleasantly wooded area then, as it is now. It was not far from the town, and so a link could be maintained with the secular world; and though the castle was still not built in its present form, the Paganel family occupied Castle Hill – thus the monks were within a stone's throw of their patron, who could look down upon the roof of the priory many feet below and congratulate himself as a worker of good things. (Even so, he seems to have been a rather niggardly benefactor, since the earliest buildings that remain are rather rough. Coarse

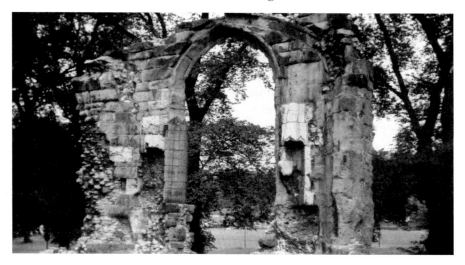

7. Dudley Priory: the lady chapel

limestone rubble was used as the basic building material, and accuracy of measurement has not always been observed.)

The priory passed through many phases. If we look at it now, we may be most attracted to the little Lady Chapel on the south east. In 1487 John Sutton (the then Lord Dudley, a remarkable character whom we shall meet later) left provision in his will for the reconstruction of this chapel as a suitable resting place for himself and his wife. Soon masons were at work modifying the south transept of the old church, putting up a new roof with high arched stone vaulting, inserting a new east window with five lights, and buttressing the exterior. Up on the wooden ladder John Colsyll could be seen fitting the coloured window. He was a much respected craftsman, who carried out contracts for glazing at Halesowen and probably also at the old Dudley parish church of St Edmund's.

Six miles away at West Bromwich, the priory of Sandwell was founded about the same time as Dudley. It is said that there was a hermitage there of old, and records tell us that a certain William de Offney gave the land to the monks. Gervase Paganel of Dudley later confirmed the grant. Sandwell fared worse than Dudley, and today there are few tangible remains of the priory. Only the names of the quarrelsome monks of the Middle Ages, scattered through the surviving documents, bear witness to the influence of Sandwell in medieval times.

Among all the religious institutions of those distant days, Halesowen Abbey outshone all the others in the Black Country. It was in 1218, three years after the signing of Magna Carta by King John, that a small band of white-robed monks arrived in the pleasant valley of the Stour to take

possession of a grant of land which the King had made to them a few years earlier. Halesowen was a small town, but a flourishing one. It had belonged since 1177 to the family of the Welsh Prince Dafydd ap Owen, who had transferred it administratively to Shropshire, in which county he held a great deal of land. The monks must have been pleased both with the town and the site – a well sheltered valley at the foot of the Clent hills, with the Stour still a small stream, suitable for damming to create fishponds, stone not far away for building, and roads that were passable though not thronged with travellers. They must also have had in mind the shrine of St Kenelm, and were glad that the manor of Kenelmstow, as part of Halesowen, was now theirs.

They were certainly taking possession of a rich gift. The lands of Halesowen manor stretched from north of Oldbury for more than six miles to Farley Coppice in Romsley, and included Hasbury, Hawne, Ridgacre (Quinton), Lapal and Warley. The monks worked hard at their site, and little by little the beautiful walls of the monastery grew, with tall lancet windows and a groined roof. These monks were nobles, and their abbots men of great power. Later in the thirteenth century some of them were called to Parliament. Despite their affluence, however, they were always entering into lawsuits to reduce their commitments. They complained that the high road (which had seemed quiet when they arrived) carried a great many travellers, whom they had to help on their way. They tried to divert the Stour between Cradley and Cradley Heath, perhaps to gain more land at the expense of Lord Dudley. They guarded their lands jealously, marking abbey territory with stone crosses and statues. Haden Cross, the base of which remains in Haden Hill Park, Old Hill, was probably one of these, and we have the names of Rood End (the rood was a medieval word for the cross of Christ) and the one-time Derickton Cross at Tividale, as well as Stone Cross, West Bromwich.

Outside Halesowen, the monks owned tithes and lands at Wombourn, Wednesbury, Walsall, Rowley, Lutley, Frankley, Harborne, Northfield, and other places in the Black Country and surrounding areas. But the fame of the abbey rested as much or more upon the miraculous relic they held at Halesowen, enclosed in a gilt and jewelled shrine – the actual head of St Barbara: complete. That the head of a Roman saint, cut off by her pagan father a thousand years previously, should come to be in Halesowen, so many miles from the scene of her martyrdom, might seem hard to swallow even in an age of marvels. But still, St Barbara was worth her weight in gold. From all over the country people came, bringing their alms as tribute. They must have derived some benefit from their pilgrimages, but the abbey probably derived more. By 1505 we find the abbey rich with silken coverlets, vessels, basins and ewers of silver, not to mention the silver-gilt

8. Medieval font at West Bromwich church in modern context

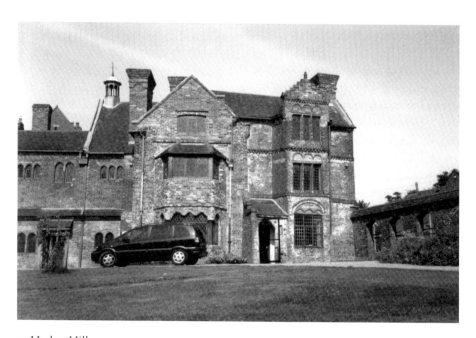

9. Haden Hill

processional crosses which preceded St Barbara's head in its casket on feast days. Though there were never more than about eighteen monks in residence, a return of 1489 gives their yearly consumption of "beeves" at sixty, together with forty sheep, twenty-four calves and thirty pigs. 1,110 quarters of barley were used for brewing and the weekly requirement for bread was twenty bushels of wheat and rye. The monks and their guests must have lived well!

It is not easy to sort out the merits and demerits of the monastic system. The Halesowen monks were hard taskmasters to their tenants, and keen businessmen. They were always involved in law cases and were very willing to take all the alms that poured into their coffers as guardians of the shrine of St Kenelm and the casket of St Barbara's head. They were not poor hermits, but enjoyed high living. On the other hand, they provided a focus both for economic growth and religious devotion. They maintained roads, kept gates such as the one at Whiteheath in Rowley, cleared the Stour of rubbish, pioneered agricultural methods, and began to exploit the minerals (coal, for example, was mined by Halesowen monks from at least 1307). They provided the genuine poor with a last refuge, and the honest traveller with safe board and lodging. They formed a counter group to the rapacious civil lords who might otherwise have had everything their own way. It would be impossible to regret them, if only for their marvellous buildings, which even today provide a moment's surprised excitement for the speeding motorist as he hurtles along the Halesowen bypass.

The beautiful buildings at Halesowen Abbey were financed through the enthusiasm and power of the monks. In the market towns to the north, Walsall and Wolverhampton, church building was advanced through the financial aid of laymen – merchants who as time passed had grown rich on the chief English enterprise of the age, the wool trade. Mid-Wales and Shropshire hillsides provided pasture for myriads of sheep, whose wool was destined to be exported to the Continent via the "bridgehead" at Calais. The organization of the trade was in the hands of a company called the Staple, with members in all the wool producing areas of England. Many Wolverhampton merchants belonged to the company, and were at first engaged in the export of raw wool; later in manufacturing wool into cloth. Through the exercise of this trade they became rich, and one of their chief beneficiaries was the collegiate church at St Peter, close by the old High Cross in the highest part of Wolverhampton.

During the fifteenth century, and through part of the sixteenth, work was carried on continuously at St Peter's, producing the building we can still see today. Generous allowances were made by families such as the Swinnetons and Levesons – rich staplers – and slowly the grand design was realized. The stone for the rebuilding probably came from a site near

to the church itself. The nave of the church was surmounted by a high clerestory, and it was completed by a tower 125 feet high, which was only just finished in time to receive the bells taken at the Reformation from the dissolved abbey at Much Wenlock. This is the Black Country's most impressive church, and though it was restored extensively in Victorian times, it must appear now very much as it did at the end of its medieval rebuilding.

Within the market towns the exercise of individual trades was governed by the local "gilds" or trade brotherhoods. Their duties included the protection of the market from strangers or usurpers and the subsidizing of religious life. Like Wolverhampton the town of Walsall (where the fifteenth century also saw a major rebuilding of the parish church) contained many rich merchants whose work was carried on through these gilds. The Walsall gilds were divided into three groups for the organization of the miracle plays, which were publicly performed at religious festivals. The words of these plays from Walsall have not survived; they were concerned with such themes as the creation of the world, the birth and life of Jesus Christ, his crucifixion, descent to Hell and resurrection. In this highly memorable manner townspeople who could not read were instructed in religious truth.

A list of the types of trade in the three groups mentioned may help to give some idea of the occupations of Walsall townspeople in the fourteenth and fifteenth centuries. The first group consisted of smiths, braziers, millers and bakers; the second of shearmen, tailors, mercers, drapers, glovers, sempsters and barbers; and the third of cobblers, bakers, butchers, carpenters and fletchers. An ordinance of 1502 shows what the gilds expected of their members:

> No man [says the ordinance in modernized form] shall set up any of the said crafts in the town or parish of Walsall, except he pay to maintain the chapel of St Katherine, and the light of St Anne in the church of Walsall, 6s 8d.
>
> There shall be no man free in the said crafts except he have been prentice in the said town or parish or else born in the said town or parish. If any man work contrary to this ordinance, the warden shall ask him to leave ...
>
> They shall keep their drinkings four times a year, every man to pay one penny at every drinking, and he that is absent to send his money or else forfeit a pound of wax to the light of the chapel aforesaid.

The gild of St John the Baptist maintained the privileges of the Walsall tradesmen, keeping away foreigners (even if they only came from

Bloxwich, the "foreign" of Walsall) from participation in the town trades. It protected widows and orphans, and paid towards the upkeep of the church. In addition to these functions, St John's gild gradually became almost the equivalent of the town's corporation, and in time the Guildhall took on the role of a town hall. Like the monasteries, the medieval gilds appeared to King Henry VIII to have too much power and wealth, and he decided to suppress them.

One other religious institution must be mentioned, the only one which was to survive the Reformation. This was the structure of dioceses and parishes, with their attendant chapels of ease. Many a Black Country town which has no other relic of the Middle Ages has at least a tower or foundations from the old medieval parish church. At Wednesbury, for example, the parish church was largely rebuilt during the fifteenth century, but one can see traces of early-English style, including a pointed thirteenth-century window. The church also contains a mysterious lectern carved from wood in the shape of a bird. Most churches have an eagle supporting the Bible, but it seems that in Wednesbury the bird may be a gamecock. It would certainly be very interesting if we could trace back the Wednesbury people's interest in cockfighting to the Middle Ages.

While the power of the church grew and then declined the power of the nobles increased steadily. As we have seen, the greatest local landowner at the time of Domesday was the Norman, William Fitz Ansculf. It is sometimes claimed that his motte and bailey castle at Dudley was one of the largest earthworks built by the Normans in England. The earliest stonework visible in Dudley Castle today dates from later in the Norman period, and was probably put up by Fulk Paganel, who was Fitz Ansculf's son-in-law. Dudley never had a great square donjon tower like the Norman castles at Rochester or Newcastle, perhaps because the artificial bank at the top of Castle Hill was not compact enough.

Throughout medieval times, there were periods when the succession to the throne of England was disputed. War was never far from the lives of the common folk, who might at any time be called upon under the feudal system to take up their weapons and leave their villages to fight in some incomprehensible struggle for their liege lord. It must sometimes have been a puzzle to the lords themselves to decide which of two opposing contenders to support. Gervase Paganel, whom we have already met as a benefactor of Dudley Priory, and who was Fulk Paganel's grandson, was one lord who chose the wrong side. When in 1173 young Prince Henry rebelled against his father, the strong and well-organized Henry II, Paganel unwisely helped the son.

Henry II succeeded in putting down the rebellion, and the men who had helped his son were punished. Gervase Paganel had to watch the complete

destruction of all the fortifications at Dudley. Great gate, screens, towers and banqueting hall too, were all battered down, leaving the hillside desolate. Hawthorn and elder rooted in the crevices, rain dashed at the mortar, the townsfolk stole building materials, and the great Norman castle at Dudley sank into decay. It was not until 1262 that attempts to rebuild the fortifications were made.

By this time the Paganel dynasty had died out, and the property passed through the female line to a family called Somery. Originally Norman, the Somerys had settled in East Anglia and had confirmed their title to Dudley by a substantial contribution to the ransom of King Richard the Lion Heart. It was the fourth head of this East Anglian family, Roger de Somery II, who began to take a personal interest in Dudley. He had apparently built a manor house there already in the ruins of the old castle. When he returned from fighting the Welsh on behalf of Henry III he determined to turn this manor house back into a great fortified castle. And though at first the King ordered him to stop building operations, Henry III gave him a licence to refortify after he had again fought loyally on his behalf (this time against the barons) and in 1265 the reconstruction of the ruin began.

During the next sixty years the Somery family laboured at the rebuilding, extorting money from the surrounding populace by fair means and foul. Roger de Somery II, for example, endeared himself to the burgesses of Dudley by granting them many commercial rights, including freedom from tolls at Birmingham and Wolverhampton markets. But his grandson John operated in the West Midlands what we should nowadays call a protection racket. A complaint laid against him by a certain William de Bereford in 1312 tells us:

> he domineered more than a king ... There was no abiding for any man in those parts except he bribed the said John de Somery for protection, or yielded him much assistance towards the building of his castle, and that the said John did use to beset men's houses in the county for to murder them.

The King took no action against John, however, and soon the castle was finished. Great curtain walls surrounded the courtyard, and the keep was completed with its dominating round towers. One can picture during times of trouble the gatehouse portcullis clashing down across the gateway to close the entrance. Looking at the keep and gatehouse block today, one can still recapture the magnificence of that age, and realize the lawlessness that compelled men to build a residence of such sturdiness.

When John de Somery died, the estates passed to the house of Sutton, who began to use the surname "Dudley" and took great interest in the castle

and borough, though they held lands elsewhere. Despite interruptions the family continued to hold Dudley until well into the seventeenth century, adding to the buildings a gracious chapel, which still survives, and an outer barbican, which was raised to the ground after the Civil War in the seventeenth century. Under the early Suttons, Dudley town grew in prosperity. The waste land was being colonized. We know for instance that in 1338 the second John Sutton leased to burgesses of the town some land which included an area described as being between the pillory, two shops and the town cross.

The most famous of the medieval Suttons was the long lived John VI. We have already seen how he left instructions for the rebuilding of the Lady Chapel in the priory to form a fit resting place for himself and his wife, and how this chapel became a beautiful monument to his memory. John divided his time between Westminster and Dudley, and was a redoubtable fighter. But he only fought when he chose to do so. When still in his twenties he defied a command to fight in the retinue of the Duke of Gloucester, and a document complains that "he tarries in his own castle". Four years later, however, he was appointed Lord Lieutenant of Ireland, and as a result of successful service there and elsewhere he was granted a state pension. In 1473 he was constable of the Tower of London, and later received many more honours, including the stewardship of Kinver forest. The Lords of Dudley had entered upon the national stage, where during Tudor times they were destined to play some lurid parts.

The closing years of the fifteenth century mark the end of the medieval period in English history. The feudal system, by which every man was bound to fight for his leige lord when called upon, began to break down as warfare became more technical. For many years even the agricultural population had been gradually freeing itself from the ties which held it to the land. This trend was very marked in such places as the Black Country, where the early working of minerals provided people with an alternative source of livelihood. The Black Death of 1349, the disturbances among labourers which culminated in the Peasants' Revolt, the spread of Wycliffite thought: these and many other influences led to the breakdown of the old order. By the time Henry VIII initiated his reorganization of the Church, medieval institutions were doomed.

Of the local monasteries, Sandwell was the first to be dissolved. In 1524 it was alleged that the monks had got into the habit of harbouring robbers at the priory. When complaints were made to Cardinal Wolsey, he ordered the monastery to be suppressed. Dudley Priory, which had retained its link with Much Wenlock in Shropshire, was involved in a quarrel with its parent house in 1521, and Wolsey was called upon to pronounce judgement. We do not know which side he upheld, but in any case the

settlement did not last long. In the middle of the next decade, it became clear that King Henry was going to abolish monasticism in England and confiscate all monastic lands.

The Halesowen Abbey lands were forfeit to Sir John Dudley, then lord of Dudley Castle and much else up and down the country. A tremendous shift in the balance of power took place. Even before the transfer the Dudleys had owned a great deal of land in the West Midlands; now they virtually had a monopoly of land ownership outside the Crown lands. Religious ornaments and furniture from the abbey were transferred to Halesowen parish church – a magnificent medieval building with a fifteenth-century tower. St Barbara's head seems to have been taken to Worcester, as account books show:

> 1539 Item.
> Expenses at carrying the relicks to the bishop ... 6d.

Another item is for "setting up all the tabulls and all the images in the church, 8s 3d". But the Reformation swept on apace, and in the account book for 1547 we find:

> Item.
> Spent in drink in taking down the images ... 4d.

10. Remains of Sandwell Priory

Religious pictures and statues from the abbey had stayed in the parish church only eight years!

And so the churches were despoiled and the monastic ruins fell into decay. Sandwell became the property of the Whorwood family of Kinver, who built a mansion on the site. Dudley Priory languished for years, then became a cottage and later a tannery. Halesowen Abbey was used as a quarry for other buildings. It is said that an eighteenth-century rebuilding of Hagley Hall used stone transported from Halesowen Abbey. The ruins that remained were overgrown with ferns and ivy, and in time a farmhouse was built there. All the splendour and power of the once great abbey was gone.

As for the recipients of the Halesowen lands, the Dudley family, they had now become one of the foremost families in the whole of England. John Dudley, Earl of Warwick, was the representative of the family who annexed the abbey lands. He was the great grandson of the long lived John Sutton VI, and excelled his grandfather in splendour, ambition, determination and craft. His first object had been to inherit the Dudley estates, centred on Dudley Castle. He had therefore made overtures to a set of moneylenders who were financing the then Lord Dudley, his cousin. He, as it happened, was one of the few Dudley weaklings. "Lord Quondam" was the name the people gave him – the has-been Lord. John Dudley lent Lord Quondam a fortune through these moneylenders on mortgage, and when the time came for the mortgage to be redeemed the takeover was easily effected. Lord Quondam died at Westminster, but John Dudley was already in possession of his property.

Although he owned Warwick and subsequently became Duke of Northumberland he writes in letters of "coming home" to Dudley. In 1540 he embarked on a great rebuilding of the castle at enormous expense. Much of this Tudor part of the castle survives, though it has not been inhabited since the terrible fire of 1750.

His grandiose rebuilding of Dudley, his acquisition of vast wealth, his closeness to the royal household: these were not enough for John. He next determined to dispossess the Tudors from the throne and exalt the Dudley family to the role of monarchs of England. Henry VIII had died in 1547, after cutting the English Church's ties with Rome and successfully concentrating secular power on his court. His successor, Edward VI, was a minor, and for a while there was bitter rivalry between John Dudley and the Duke of Somerset for supreme power in the land. It was Dudley who eventually gained the young king's trust and became his right hand man. In 1551 he became Duke of Northumberland. Somerset was almost immediately put on trial on an invented charge of trying to overthrow the government, and his execution in January 1552 left Dudley as sole effective ruler.

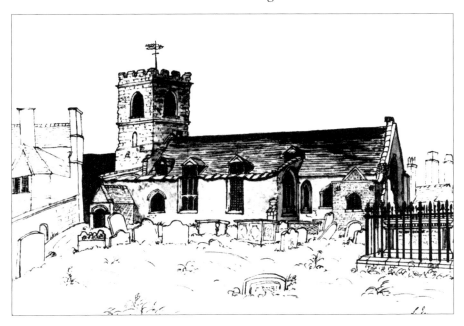

11. Old St Thomas' Church, Dudley

However, Dudley knew that he could only enjoy his control of England so long as the ailing King Edward VI was alive. On his death, by the provision of Henry VIII's will, the throne would pass to the redoubtable Mary, and Dudley's power, if not actually his life, would be spirited away. By early 1553 it began to look as though Edward would soon die. John Dudley then formed the desperate plan of marrying his son Guildford Dudley to Lady Jane Grey and persuading Edward to bequeath her the English crown. The marriage duly took place, and on Edward's death Jane Dudley was proclaimed Queen. Mary, however, had escaped from London, and when the Duke marched with his army to meet her in battle the populace eagerly aligned themselves with Mary. The battle never took place, and within a few days Dudley was in the Tower of London. On 22nd August he was executed for treason. All his estates were confiscated and held by the Crown until Queen Mary restored them to Edward Dudley, son of Lord Quondam.

Although the Sutton line continued to play an important part in Elizabethan politics, they did not again attain the giddy heights or drop to the shameful depths reached by John Dudley, and by the end of the sixteenth century the family was impoverished and obscure. Forty years later the Suttons were to die out and be replaced as landowners at Dudley by a merchant family named Ward.

RELIGIOUS DISSENSION

King Henry's dissolution of the monasteries did not result in a decline in religious influence on the state. On the contrary, it became all the greater. Throughout the rest of the sixteenth and much of the seventeenth centuries, men's opinions on religious matters were so opposed to one another and so fiercely held that many bitter deeds were done in the name of God. Some who were involved in religious intrigue were mere adventurers, but others were sincere men filled with zeal for truth. Their only mistake was not to realize that you cannot change men's opinions by cutting off their heads.

Not everyone accepted Henry VIII's reforms. Inside England, when Queen Mary succeeded Lady Jane Dudley, strenuous moves were made to reverse them. The Pope, too, was not going to tolerate England's defiance. He arranged a pact between the Emperor of the "Holy Roman Empire" and the King of France with the aim of invading England. King Henry issued an order that every man of able body above the age of sixteen should be armed and keep up constant practice with the weapon best suited to him. The Tudor "Home Guard" thus inaugurated continued its practice for fifty years; only when the glorious Armada of the Spaniards was defeated in 1588 could the country relax its watch against the Catholic countries of Europe. Slowly, during Queen Elizabeth's reign, the population became accustomed to a reformed Church, and opposition quietened.

The muster rolls of this Tudor citizen reserve are still available. Through them we can tell what were the chief weapons in use, and what were the names of the principal inhabitants. In the little hill village of Rowley Regis there were fifteen people on the muster roll. Most of their surnames are still common throughout the Black Country. William Orme and Henry While both had a gesturne (a leather jacket), a salett (helmet), splentes (for the arms which would otherwise be unprotected), and a bill (a long pike with a barb on the end, so that an enemy could be hooked off his horse and finished off on the ground). John Grove's armour was very similar. John Darby had a salett and splentes, Thomas Russell a bow and arrows, and

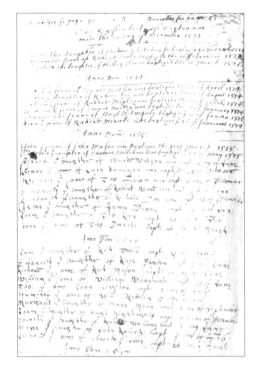

12. Tipton Parish register

Thomas Cartwright a bow. Richard Haden and Thomas Horton each had a sword, while George Allchurch and Thomas Parkes possessed daggers. Henry Cattell and George Martin had splentes only, John Mansell a gorgett, John Hodgkiss a salett and John Addenbrook a sheaf of arrows.

In many ways the sixteenth century is the time when we see the individual emerging as a person from among the crowd of men and women with whom earlier history deals. Records of several new kinds were kept from about this time. In 1538, the year before the muster roll, many parishes began to keep parish registers. This was, in fact, a legal duty, though not every village complied, and some registers have been lost. But by 1600, we have records of the christening, marrying and burying of innumerable Black Country folk who had no very great importance in history, except that they were its very backbone. The land could not have been tilled, the quarries dug, houses built, metal forged, wars fought, without the hard work of this great army of people, of whose lives the parish registers tell us the very briefest outline.

A document that helps us to fill in the bare outline is the will and probate inventory. For example, here in Rowley Regis is a rather obscure man called John Turhill, who appears in the parish register when his four little girls are christened between 1547 and 1557. He would be only a name, except that a copy of his will and an inventory of his goods at the time of his death survive. He left his eldest daughter, Amy, two pieces of land and:

a bedroome in the kitchen beneth the entrie conteining eight feet square on the South side of the house with free egress and regress ... with a place to sit in by the haule fire and the said Amy to enter upon the said bed roome and liberty to sit by the fire immediately after my decease.

This provision was, however, to be withdrawn if Amy married.

The second daughter, Joan Turhill, was given two pastures and a cow "call Ffylpayle". Let us hope she lived up to her name! The third daughter was given two pastures, while the fourth, Elinor, was left a calf called Daybell, together with £5. The fifth daughter, who was missed out of the parish register, was called Isabel. She also received a cow on her father's death. As for John Turhill's personal belongings, we know only that his "saddle, boots and spares" (spurs) were given to an executor, John White of Oldbury.

So, in the sixteenth century, through inventories, muster rolls, poll taxes, land transfers, and other documents, the ordinary inhabitants of the region begin to live for us. Returns to the Bishops of Lichfield or Worcester (the Black Country was divided between two dioceses) show who refused to go to their parish church on grounds of conscience. As well as ordinary village folk, these returns indicate the names of the Catholic gentry, who would be suspect politically as well as in religion, and who were soon to have a chance to demonstrate their loyalty in a crisis, in the aftermath of the Gunpowder Plot of 1605.

During the last years of Elizabeth's reign her organization of the Church of England had been under attack from two quarters, the Catholics, who believed that since Elizabeth's excommunication the English Church was divorced from truth, and on the opposite side the Puritans, who wanted an end to the system of bishops and priests, broadly favouring a democratic form of Church called Presbyterianism. Elizabeth died in 1603, and the Stuart house reigned instead. The Gunpowder Plot was an attack upon them from the Catholic wing, while the Rebellion and Civil War of the 1640s was an attack from the Presbyterian wing.

Although Guy Fawkes himself had no Midland connections, many of his fellow plotters were Midlanders. Chief among them was Robert Catesby, the heir of a Warwickshire squire, who was a close friend of the Lyttleton family. When Guy Fawkes failed in his attempt to blow up the King and Parliament, some of the conspirators fled to Holbeach House, near Himley, which was the home of Stephen Lyttleton. The King's men, aided by forces from Worcestershire, set off in pursuit and surrounded Holbeach. All this set a problem for Sir William Whorwood of Sandwell, Sheriff of Staffordshire. He was certainly no Catholic, but found the pursuit, capture and execution of his neighbours in Staffordshire not at all to his taste.

Sir William absented himself from the attack on Holbeach House, where in course of time Catesby and three other conspirators were killed. Stephen Lyttleton and Robert Winter escaped the encircling party and in the cold December weather they made their way by side lanes to Rowley village where they took refuge with Christopher White, a yeoman farmer. In his barn, and later in the outhouse of another farm in the village, the fugitives lay in hiding. Meanwhile the Privy Council sent the Sheriff a letter in which they demanded a quick arrest. But still Sir William Whorwood was disinclined to persecute the plotters.

After a while, Lyttleton and Winter decided to move across country again, this time to Hagley, where at Hagley House lived Stephen Lyttleton's relative and sympathizer, known as "Red" Lyttleton. This time it must have seemed a safe refuge, but a gossiping cook found out in less than a day who the mysterious guests were and the pair were soon arrested. "Red" Lyttleton escaped to Prestwood near Stourbridge, but was captured there and taken to Worcester, where he was tried on a charge of High Treason and executed. Those of the plotters who remained on the Staffordshire side of the boundary had an advocate in Sir William Whorwood.

A special court was held at Wolverhampton to try the minor accomplices from Rowley, while the principals, Lyttleton and Winter, were sent to London where they were executed at St Paul's late in January 1606. Sir William Whorwood advised the judge at Wolverhampton that there was a case for releasing Thomas Smart, one of the Rowley men, as he had openly talked of giving up the plotters to justice. But the Sheriff's advice was not followed and both Smart and the other man from Rowley, one Hollyhead, were executed on High Green. It seems that Sir William had already made one attempt to let all the Gunpowder Plotters escape; it is recorded that in a meeting with Sir Edward Leigh and Sir William Wakering, two other South Staffordshire magistrates, he had proposed to call off the chase entirely. He was by no means the only Staffordshire magistrate to take a lenient view of his friends' religious allegiance. It is recorded that Sir Walter Leveson of Wolverhampton was also in the vicinity when Holbeach was being stormed, but pretended to other pressing business. Both he and Sir William Whorwood were soon removed from their posts because of their leniency.

King James I had survived the Gunpowder Plot, but religious problems continued to harass the monarchy. When James died his son Charles shocked Puritan and even some moderate opinion by marrying a French Catholic, Henrietta Maria. He became less popular still when he dispensed with parliamentary government. This measure was accompanied by heavy taxation, notably on wealthy traders who held their own freehold. There was also a new tax called "Ship Money", again payable by the richer

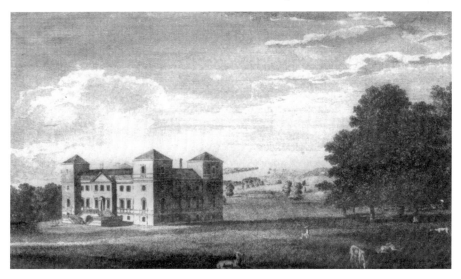

13. Hagley Hall, seat of the Lyttletons

inhabitants. Although evidence from Walsall suggests that the Sheriff of Staffordshire did his best to tax fairly, any tax is resented if it seems likely to be permanent. And it seemed very likely that this would be true of Ship Money.

Matters came to a head during the sitting of the "Long Parliament". This had as one of its aims to heal some of the rifts that had opened between King and People (the more influential ones) during King Charles' reign. On the surface, the Long Parliament was settling constitutional matters, and its breakdown brought a constitutional crisis. But behind the constitutional question lurked religious issues, and these were increasingly prominent as the Civil War gained momentum. During the war, tensions which had been present for a hundred years, since the days of King Henry VIII, flared up in bitterness. In the West Midlands the shattered ruins of Lichfield Cathedral, the pillaging by Royalists of St Peter's Wolverhampton, the deliberate destruction of St Edmund's Dudley show how the war took toll of religious buildings. Among secular buildings garrisoned and damaged in the Black Country area were Dudley Castle, Bentley Hall and Stourton Castle.

The Civil War in the West Midlands developed in much the same way as in other places up and down the country. Local gentry quickly took sides, garrisoned their manor houses, went forth to attack the manors of other local gentry, and eagerly awaited the arrival of the King, Prince Rupert, or Roundhead leaders such as the Earl of Denbigh. The King's first

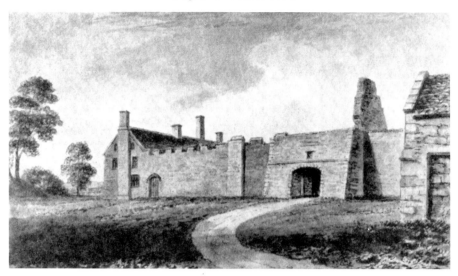

14. Rushall Hall

appearance here was when he marched up country in 1642 and stayed for a short while at Kingstanding, near Great Barr, to review his soldiers. The review passed off without trouble and the King continued to Shrewsbury. But during the next year, about Easter, Prince Rupert skirmished neat Birmingham, leaving the town a smouldering ruin, and then marched to the north to present himself before Rushall Hall, near Walsall.

Rushall was the home of Sir Edward Leigh, a scholarly and moderate Puritan. He was much happier studying Greek and Hebrew than waging war on Royalists. At the age of twenty-six he had been arrested for the unlikely offence of playing bowls (unlawful at the time) at Bloxwich, but lost his case when he sued for wrongful arrest. Thereafter he had gone off to Oxfordshire for a while to practise law and read the Bible in the original tongues. When the war broke out he was made a colonel by the Parliamentarians, joining the very man who had arrested him, Henry Stone. These two led the "Safety Committee" which seized Stafford at the outset, and thus put local Royalists at a disadvantage.

It was while Edward Leigh was up at Stafford that Prince Rupert appeared. He found Rushall Hall fortified but unguarded except by Mrs Leigh and her servants. It was an easy matter to take the hall, which was then handed over to a local Royalist commander, Colonel John Lane of Brewood. For a year Rushall was a Royalist outpost, wreaking havoc on Parliamentary munition and supply routes in the Cannock Chase district. It was not until the Spring of 1644 that Edward Leigh felt free to consider

the relief of his home. By this time it had become clear that such a well placed house must be regained, and the Earl of Denbigh was sent to carry out this task. His forces reached Bloxwich at night, and encamped a mile away from the hall, looking down on Rushall from the sloping ground at Harden. The following Monday they marched to the hall with artillery and broke down the defence walls. Lane was allowed to leave unharmed, but the weapons were forfeit to the Roundheads.

A new master, Captain Tuthill, was in command of the garrison at Rushall. He was a tough soldier, and he had permission to levy money for the soldiers' wants from a wide area, including Aldridge, Barr, Rushall, Walsall, Handsworth, Tipton, Willenhall, Wednesbury and Bentley. "He did swear and blaspheme as if he would cause the stones to fly out of the walls," says a man named Francis Pitt, who witnessed him at it. When Pitt remonstrated, he was stripped and beaten. According to him Rushall was full of swearing, drunkenness and profanity, despite an edict from Sir Edward Leigh and the Committee that this kind of offence should be punishable by a fine or, if it were twice repeated by the soldier having a hole bored through his tongue and dismissed. It is possible, though, that Pitt was not a true witness. He was employed by the Royalist Colonel Leveson, then in command at Dudley Castle, to see whether Tuthill would sell Rushall to the Royalists for £2,000. Negotiations began, but in the end the Wednesfield farmer Pitt was no match for the superior treachery of Tuthill, and he was taken to London, and executed for his treacherous dealings on 12th October 1644.

The following year King Charles himself was in the Midlands. In May he moved up from Oxford towards Leicester. On the 14th he was at Cofton Hackett and the next night he slept at Himley. On the 16th he was quartered at Bushbury, near to Prince Rupert's headquarters in Wolverhampton. After taking Leicester on 31st May 1645, he suffered a crushing defeat at Naseby near Market Harborough in Northamptonshire and from this time must have seen his doom dearly.

Hatreds persisted among the local gentry, and the fortunes of moderates like Sir Edward Leigh fluctuated with the times. He was one of Cromwell's more thoughtful adherents, and though he had been a member of the Long Parliament in 1641, he did not support extreme measures and was among Presbyterians who in 1648 were expelled from Parliament. He lived until 1671, when he was buried without a memorial stone in Rushall old church. He had been biblical critic, barrister, Member of Parliament, joint organizer of the Safety Committee, scholar and adviser to the Parliamentary faction. His life had been dedicated to the belief that man advances by the pursuit of reasonable ends through moderation and tolerance. The Civil War was a blot on this theory that must have left him unhappy, yet it was through

such people as himself that England struggled from privilege, greed and barbarity towards the goal of individual responsibility and democracy. In him Rushall has a "mute inglorious Milton" to be proud of.

Meanwhile King Charles I's life was drawing to a close. At first the Independents under Cromwell had believed it possible to restore him to power with his right much curbed. But even in his hour of defeat he continued to intrigue with both sides and they finally saw no course open but to execute him. His death proved a great shock to all sections of opinion, even in such troubled times. In particular, the Scots repented of their action in helping the Independents to lay hold on Charles I, and set up his son, another Charles, as King. It was many years, however, before Charles II was to be recognized as King of England.

The death knell of Scots' hopes of setting Charles on the English throne came at Worcester in September 1651. Their army had marched into England through Carlisle, Warrington, Whitchurch and Wolverhampton, then on by way of Kidderminster. Little support had been forthcoming on the journey. The defeat at Worcester was predictable; thereafter the defeat became a pitiful rout. The young King lost himself near Kinver and after considerable wandering reached Boscobel where, as most people know, he spent a day hiding in a venerable oak tree. Next day he hung miserably about the grounds of Boscobel House, after which he was secretly conveyed to Moseley Old Hall on the other side of Wolverhampton. Here he spent several days fearfully watching for soldiers to arrest him. Then he escaped to Bentley Hall, where he stayed a night. He left the Midlands disguised as a farm worker, en route for Trent House in the West Country, from which place he was eventually smuggled to France. Parliament's hold on England tightened.

Under the Commonwealth, which was dominated by Cromwell's Puritan adherents, many attacks were made on the Church and its institutions, and almost incredible enthusiasm was shown for harassing the ordinary people in their sports and pleasures. Locally, Wolverhampton morris dancers were prevented from engaging in their seasonal custom in 1652, and when some young people erected a maypole in the centre of the town, they were summoned before the justices. Their defence was that they were celebrating the dissolution of Parliament with a dance, but the Wolverhampton Puritans divined a sinister plot. The affair led to a minor riot against the Parliament, and troops had to be sent in to "suppress the tumult".

On 24th August 1653, an Act of Parliament was passed which abolished church marriages, substituting a civil marriage contract. Instead of banns in church the couple intending to marry had to publish their names on three occasions in a local market place, after which they had to be married

by a magistrate at his own house. Magistrates were few and far between, and the bride and bridegroom might have to journey eight or ten miles. Among the justices who performed marriage ceremonies in the Black Country area were George Brindley of Kinver, Henry Stone of Walsall, John Whorwood of Dunsley and John Wyrley of Hamstead.

There was great rejoicing when in May 1660 the monarchy was restored. King Charles II, who had lived on the Continent since his ignominious defeat in 1651, set foot again in England on the 25th, and was acclaimed King on the 29th. For many years celebrations were held on this date to mark the Restoration. In 1668, for example, Bilston bellringers were paid two shillings for ringing on this day, and the custom was maintained until 1706, when an annual bonfire was also inaugurated at Bilston. In some ways the jubilation was justified; Charles behaved leniently towards his former enemies. But there was still religious intolerance: in 1662 there was passed an "Act of Uniformity" which compelled clergy to conform closely to the prayer book. This outraged Presbyterian ministers, and in the country as a whole about 2,000 are said to have resigned rather than submit to the act. Among those who left churches in the Black Country were William Fincher of Wednesbury, John Bassett of Cradley, Richard Hilton of West Bromwich, Richard Hinks of Tipton, Thomas Byrdal of Walsall, John Reynolds of Wolverhampton and William Turton, member of an old West Bromwich family, who was at the time incumbent at Rowley Regis.

New methods of taxation were also introduced. The Ship Money was gone, but in its place the King levied a tax on hearths. Many returns for this "hearth tax" are still in existence, and can be used to work out the population of various towns at the time. Every householder had to be listed, including those exempt from payment because their income was below twenty shillings a year. From these returns we learn that in 1664-5 Wolverhampton had 858 houses, Walsall 645, Dudley 535, West Bromwich 311, Wednesbury 218 and the scattered parish of Tipton only 115.

Many houses listed in the hearth tax returns are still standing. They are not easy to recognize because the only identification made in the list was the owner's name. One house in West Bromwich that was certainly included was the Oak House. Its name may have originated from the great oak tree that used to stand on the green in front of the house. It was one of many oaks that grew on the estate of the Turton family and had certainly been there since the time of the Civil War. The Turtons were staunch Parliamentarians, and if we look up today at the strange half-timbered lantern turret apparently perched on the roof of the house, we can imagine John Turton's servants in 1643 shading their eyes against the morning sun as they looked towards Birmingham where Captain Robert Turton tried to stop Prince Rupert's advance.

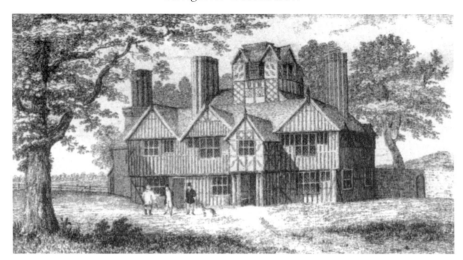

15. Oak House

The Oak saw many generations of Turtons come and go, until in the eighteenth century the family name faded out with an illegitimate successor called Whyley. He chopped down many of the oak trees on the estate in 1768, and it is said they were made into lock gates for the new canal then being built. Thirty years later the great hollow oak on the green caught fire. It was a spectacular show, with flames shooting high from the hollow trunk until surprisingly quickly the great tree was eaten by flame and collapsed into a charred hulk. When Mrs Jane Whyley died in 1837 the house passed through several hands and became very neglected. Old windows were blocked up and beautiful wainscotting spoilt by being daubed with paint. Finally, Alderman Reuben Farley gave the house to the town, and it was formally handed over in 1898. A house which had witnessed the proudly independent but politically turbulent sixteenth century and the strife-ridden seventeenth was thus saved for us to visit and enjoy.

The Civil War had been fought, the Restoration had been achieved and toleration for opposing points of view grew despite the Act of Uniformity. But the influence of religion was still a vital factor in the last quarter of the seventeenth century, both for good and ill. Everywhere, men were sure that God worked through history and would also perform miracles of all sorts. The Bible had perhaps replaced the images of pre-Reformation times as an object of veneration. Where once St Barbara's head in its casket had seemed most attractive and powerful, now the people's awe was aroused by the printed word of God, which they were beginning to be able to read for themselves. A surprising number of yeomen left a Bible to close relatives

in their wills, and some left books of biblical commentary also. And if the Bible was a most sacred object, then the punishment that awaited anyone stealing a Bible might be a supernatural one.

For example, a story is told about one John Duncalf who, after stealing a Bible from Mrs Margaret Babb just outside Wolverhampton one day in the early part of 1677, swore to God that he had done no such thing. If he had stolen a Bible, he wished his hands would rot off. The extraordinary thing is that by the end of June he was dead and buried, and the curse he had put on himself had come to pass – his hands had rotted away. The affair caused such a stir that the local parson, James Illingworth, wrote a full account of it and had it published the following year by a London publisher.

Apparently, Duncalf had been born at Codsall near Wolverhampton, and had early taken to wandering. There was little to recommend him as a young man: he was handsome in a way but apt to be sulky and idle. Nevertheless Thomas Gibbons, wheelwright of Kingswinford, set him on as an apprentice. He seems to have worked fairly well, and would have been a satisfactory workman except that he and his fellow apprentice began to steal from their master. They were arrested and charged before Lord Dudley; the offences were proved and the apprentices sent to prison. Not long afterwards, however, they were released on grounds of illness – though whether this was real or imaginary it is hard to tell.

John Duncalf decided not to go back to Kingswinford where people had found him out, and after releasing himself from his indentures of apprenticeship, he began to live the life of a vagrant, drinking, swearing, living by theft and his quick wits. In particular, he found he could cash in on the shortage of Bibles at a time when they were becoming as vital as a talisman to every local household. He began to steal them and sell them to the first customer he found.

His mistake was made in selling a Bible that could easily be recognized. A maid at John Downing's house was the recipient of a Bible stolen from Margaret Babb, who recognized her own property a few days later when she happened to call. Mrs Babb bought her Bible back, but the story spread abroad and became known to a certain Mr Evans of Himley who knew John Duncalf very well. The downfall of the handsome thief was now at hand. Mr Evans and his son went to see Duncalf and accused him directly of the theft. Duncalf swore at them, not unexpectedly. The Evanses repeated the accusation calmly, but the vagrant flared up in wild anger and began to shout and rage. "If ever it was I that stole the Bible," he said, "I wish my hands which committed the theft would rot off."

The story goes that in the middle of his curse he stopped as though thunderstruck, gazing in terror at his hands. He knew that he had stolen

the Bible in question, and he began to feel at once a sharp tension in his wrists, which increased to a numbness that made it difficult to move. His accusers were so abashed by this extraordinary outburst and its sudden interruption that they did not pursue their attack any further. After a while Duncalf went to Dudley, where he found work with a carpenter named Thomas Osborne. Here he stayed for a fortnight, but the malady in his wrists was now getting much worse and he finally shambled out of the workshop, making for his own home village of Codsall. He never reached it. On the way he was taken ill with a throbbing in his wrists and a constricted feeling as though a rope were round them, being tightened. He staggered into a neighbouring barn and lay there till a farm labourer found him after three days.

The men of Tettenhall met and asked him where he came from. In those days poor people were a great burden on the small parishes, and a system had been worked out whereby anyone who moved had to bring a settlement certificate giving his parish of origin. For some reason, John Duncalf must have been recognized by the parish of Kingswinford, for he was transferred there from Tettenhall in a cart on 28th March. Here he was put in a barn at Wall Heath where he lay inert, an object of curiosity to anyone who heard about his plight. And gradually, as people came from far and wide to look at this marvel "like a poppy show at a fair", his hands grew rotten and withered, decaying before everyone's eyes.

From the end of March until the middle of June he lay there, visited by common people who wished to see a portent, and by clergy who were actuated by duty in trying to save his soul. He took little notice of any of them, except that he reacted fiercely at first to the curious stares of the men and women. His reputation in the neighbourhood had never been a good one, but now all sorts of stories were told about him, connecting him with the devil and witchcraft, robbery, murder, and every crime under the sun. Despite the pressure on him to admit some of his crimes, he refused to do so, and denied he had ever stolen the Bible. At the end, however, he broke down and confessed his crime, after which deed he seemed to be calmer, and it looked as though he might die peacefully. His hands were now quite rotten, hanging by a mere thread. Finally he asked his attendant, one John Bennet, to cut off first one, then the other. The curse had been fulfilled: his hands had rotted off.

Still he lingered, and was seen many times by the Rev James Illingworth, who tried to bring him some comfort. There was a proposal to call in doctors to help him (only now, when he had no hands!) but apparently this was not acted on. And so he died on 21st June 1677, "to give a warning to posterity," as Illingworth wrote in the parish register, "to beware of false oaths". At times one wonders whether this was not, in modern terms a

"frame-up". The surprising thing about the whole case was that none of the gentlemen who called to see him made any useful proposal concerning Duncalf: they all harangued and verbally assaulted his soul, but no one sent for medical help. They were perfectly certain that the expiation of his sin of blasphemy was much more important than his physical condition. And in this they were typical of their century, the century which could execute the Gunpowder Plotters to the last man, plunge the country into Civil War for an ideal, and behead the King himself for religious beliefs.

4

A CLEAR BRIGHT FLAME

If it were only religious or political history which had to be told, you might well imagine that the story of the Black Country was no different from that of any other part of England. Every county had a tale to tell of Civil War times; all had castles ruined and churches destroyed in the anarchic mid-seventeenth century. But the Black Country was one of the seed-beds of modern industrial society. Other forces were stirring here apart from religious and political ones. As we saw, miners and quarrymen were active as far back as the thirteenth century, and from those times on the charcoal burners were making their way through the woods, cutting down the oaks and beeches. Not surprisingly, by the late sixteenth century oak woods were becoming scarcer, and the difficulty of obtaining enough fuel was increased by the introduction of a new method of producing iron.

At first the charcoal made by the toil of the charcoal burners was used in a bloom-smithy. This was a small furnace in which the charcoal was heated by hand bellows, and a fire was generated hot enough to fuse the ore and produce lumps of iron called blooms. These were then purified of dross by hammering. The resulting iron could be wrought into shape there and then, and bars of iron or small objects such as horse-shoes were produced. But towards the end of the sixteenth century the blast-furnace was introduced into the Midlands. In this furnace a very strong draught of air was created, which caused a great rise in temperature. This meant that the iron melted completely, and it could be cast. Later, it could be reheated and hammered in a forge, so that very tough iron was made.

The owner of the first known blast-furnace in the Black Country was Sir William Whorwood, whom we have already met acting (or rather failing to act) in his capacity as Sheriff of Staffordshire. In 1597 he had been involved in a running fight which shows how jealous were the rivalries among the iron producers at this time. The quarrel presumably resulted from the fact that both Sir William and his rivals were using local sources of charcoal and iron ore. Whatever the cause, on 8th July 1597, Thomas and Richard Parkes of Wednesbury, together with a gang of their employees, wandered

16. River Tame

over to Perry Barr, where Whorwood had his blast-furnace on the banks of the Tame. They broke into the building, barricaded the doors, and refused to let the lawful occupier in. A great deal of damage was caused.

Sir William was not a man to be easily roused, as we know from his subsequent dealings with the Gunpowder Plotters. But this attack angered him very much and he contacted his landlord, Sir Robert Stamford of Birmingham. The two men got together a collection of fourteen of their most trusty servants and tenants and set out for a forge on the Handsworth side of the River Tame which belonged to the Parkes brothers. With them they took a roomy ox-cart, and when they arrived at Handsworth they removed a huge bar of iron weighing a thousand pounds, thirty-seven smaller pieces of iron, a large forge hammer, several sets of bellows and various fire irons. They loaded these into the ox-cart and began to move off. One of Thomas Parkes's men, named Edward Ashmore, strongly resisted them, but he was overpowered and the avenging band moved on to a blast-furnace owned by the Parkes brothers, which they also attacked. The following day an assault was made on an iron forge at West Bromwich tenanted by Thomas Parkes, and though there is no direct evidence to link this with the previous events, it was almost certainly connected.

Sir William also worked a forge at Wedhesbury, perhaps the one on the River Tame later known as Wednesbury Forge. Three days, after the assault at West Bromwich, a mob of labourers acting under the instructions of Thomas Parkes descended on the forge and disturbed manufacture there,

17. The *Red Lion*, near Wednesbury Forge

again destroying and stealing. One final attack brought the wheel round full circle. On 19th July Edward Ashmore of West Bromwich, who had been smarting from the insult accorded him when he tried to save his master's furnace at Handsworth, marched purposefully to the Perry Barr furnace, the site of the first breach of the peace, and occupied it with a crowd of labourers. This time he did not give it up, but stayed there almost a month, until Sir William was forced to go to law about the whole situation.

This silly squabbling seems to us undignified and unbefitting respectable men. It is fairly typical of the kind of exploits entered upon in those days, when there was only one constable in each town, and the processes of law were long and uncertain. But the odd thing is, that while these men were quarrelling over charcoal, there was a store of fuel available in the shape of coal if only they had known how to use it to smelt iron. At this point in history there stepped on to the scene a strange and flamboyant character, determined to solve the problem. When old Lord Edward Dudley died in 1586, possessed of a considerable iron business, his will contained the clause:

> I wyll and bequeathe my hoole yron workes with all my owre [iron ore] fytt for to mainteyne the same, and also all my woddes and underwoodes for the thoroughe mainteyninge of the same, which I doe gyve and bequeathe unto Mary ladie Dudley my wyfe, and to the lorde Charles Howarde, Highe Admirall of Englande.

Despite this provision for his in-laws the iron works came into the possession of the last Lord Dudley of the Sutton line, and through him to his illegitimate son, Dud.

Dud Dudley was noted for his spirit, acumen and pride. As a youth he had roamed his father's estates at Pensnett watching the charcoal burners and studying iron smelting. It seemed to him that smelting by charcoal had better soon be replaced, or there would be no trees left. It must have been with a sense of importance that he swaggered home from Oxford in 1619 at the age of twenty to look after his father's iron works. Applying his mind to the task, he invented a method of smelting iron which satisfied him, using coal from local pits. Many years later he wrote an egotistic book partly to let the world know about this process. But his account is so muddled and vague that scholars of industrial history still cannot be sure what it was that he invented. It seems possible that he burned small coal or slack in such a way that it coked, and that this coke was then used in the furnace. If so, he must have been very lucky in the attendant minerals.

He applied for a patent, which was granted in 1621, after King James had ordered iron of various sorts produced by Dud's process to be rigorously tested. It probably seemed as though his fortune was made. But the following year floods roared down the Stour valley from Halesowen, and swirling past Corngreaves swept away the best part of his equipment at Cradley Forge, so that Dud had to start rebuilding. Local iron-masters were jealous of this new invention and began to harass him by legal processes. But Dudley had no tact. Almost at every turn he seems to have provoked their wrath, and spent considerable time in debtors' prisons when their wrath prevailed.

He decided to set up another furnace, this time at Askew Bridge in Sedgley. His process again produced iron, but rivals once more disparaged his work and, when they had no success in using words, behaved just as the Parkes brothers had done, and attacked the furnace. During the Civil War Dud Dudley was forced to lie low. As a Royalist he received even less sympathy at the hands of his Parliamentarian neighbours than as an upstart industrialist. But when the troubles were over in 1660 he sent to Charles II for support on the very day the King returned from exile. It was not surprising that Charles showed no interest, and a few years later Dudley wrote the bitter pamphlet Metallum Martis already mentioned.

Dud Dudley died at the age of eighty-five and was buried in Worcester Cathedral. Whatever the secret of smelting by "pit-cole" it died with him, and in many ways he failed to do himself justice. It is said that he was a quarrelsome and haughty man who had inherited little from his father but the desire to live expensively and a lack of modesty. Nevertheless he did have faith in industrial advance. If only his powers of persuasion

18. Priestfield Iron Works

and conciliation had been equal to his persistence, he could have made a fortune.

Not all his neighbours were hostile to Dudley. A certain "great Dealer in ironworke", Richard Foley, leased a furnace and mines from him in 1627 for a total of £120, plus twelve pence for every bloom or load of iron produced. This Foley was another extraordinary man of whom various conflicting legends are told. Whatever their truth, he must have been a very enterprising and eccentric product of the Midlands who, unlike Dud Dudley, profited from his enterprise. His feat was to introduce the slitting mill into the Midlands. The purpose of the slitting mill was to slit bar-iron into long rods out of which nails were made. The mill made use of water power and was thus a considerable advance on the hand processes which were then being used.

According to one story, Foley stole the details of the slitting mill from Sweden. He first travelled to Hull, then took a passage on a small ship, and on landing in Sweden he put on beggar's clothes. He had brought a violin with him from Dudley, and he danced along the roads towards the iron works, fiddling in more ways than one. While the simple English beggar charmed the Swedes with his music, he learnt the secret of the slitting mill. Unfortunately, the story goes, he had forgotten to note down all the details and his first attempts to build a mill failed. So he returned overseas and busked his way right up to the Swedish mill itself. He artfully cadged a night's lodging at the mill and during his stay jotted down the results of his espionage on paper.

19. Types of nails

Another version of the story replaces Sweden with Holland and the fiddle with a flute. But here again a second visit was needed. These legends seem to indicate, at any rate, that it was Foley who introduced the slitting mill to the Midlands, probably direct from a continental source (though it was already known in the south of England). Some strange hint of the method by which he had acquired the secret must be hidden in these references to musical instruments. Whatever his method, it is as "Fiddler Foley" that he is known in local legend.

When Foley returned from the Continent his mill did well and he became Mayor of Dudley in 1616. He was soon a man of considerable wealth and in a few years he was building seats for himself and his wife in St Thomas's Church. Mrs Foley was the daughter of William Brindley of Kinver, who is sometimes also credited with a foreign journey to find out the secret of the slitting mill. It was at Kinver, a few miles from Stourbridge, that Foley's first slitting mill had been set up. Thomas Foley, Richard's son, amassed such a fortune that he bought Witley Court in Worcestershire and was frequently seen in society in London. There he met Samuel Pepys, the diarist, and there are records of his selling Pepys various items of iron, a curious iron chest, and a box with a "great variety of carpenter's tools", which greatly pleased Mr Pepys. Within a century Foley's descendants were barons. One legacy the family left to Stourbridge and district was the school called Oldswinford Hospital, which has educated many an orphan in reduced circumstances over the last three hundred years.

Richard Foley may have been the most remarkable nailer of all, but there were many men in the nail trade who flourished at this time and for many years to come. The nails for Hampton Court had been sold to Henry VIII by Lord Dudley: these would have been made by peasant workers at various places on the Dudley estates. Most people in the Black Country during the sixteenth and the seventeenth centuries had some workshop and smithy tools recorded on their probate inventories at the time of their death, even if their official description was "yeoman" rather than "nailer". The vast majority were content to accept the name of nailer; for example, in Rowley Regis, when trades were given during the Commonwealth period of the parish register, thirty-seven out of fifty-one described themselves as nailers.

The life of a nailer and his family was certainly a hard one. The nail rod had to be taken from the nail-master, cut into pieces of correct length, and hammered into shape. These processes were carried on with the aid of simple equipment in the "shop" attached to the house or later at the bottom of the fold or yard. But a significant number of people combined nailing with small farming, and the nail trade was especially suitable for this. The man of the house could work at two trades, spending wet days at

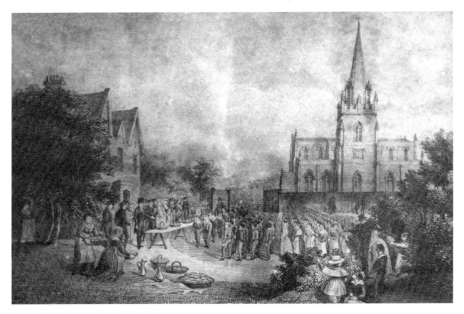

20. Sedgley Church

the bench and fine days in the fields. His wife and children were always at work, not far from their other duties, both domestic and agricultural. In this way enough was made to live on. There was no need for emigration, since children could be absorbed into the work as they reached the necessary age. However hard the job, at least it gave security and constantly available work at home, without the need to travel.

In later years a ballad contrasted the poverty of nailers with the affluence of the colliers. But in the seventeenth century there was little to choose between these trades, and if anything it was harder to work as a collier. This dangerous, romantic, wasteful yet continually alluring occupation, in which the workers became a clique turned in upon themselves, was becoming much more widespread in the seventeenth century. It was the "thick coal", sometimes called the thirty-foot seam, which made the area prosperous. Nowhere else in the whole of England was there so rich a seam, ten whole yards of glistening black to be quarried and used for domestic fires, and now increasingly for industrial purposes too. As we have seen, in places where the seam "outcropped", reaching the surface of the hillside, it had been mined for centuries. In the northern half of the area coal was being mined in Sedgley, Coseley, Bilston and Wednesbury, while in the south Netherton and Halesowen were two main centres of mining.

Dr Plot, a chemist from Oxford, studied the way in which mining was carried out, and in 1686 published what he had seen in his *Natural History*

of Staffordshire. He reported that at Wednesbury the colliers first removed the topsoil, then stood in the trenches they had made and dug the coal underneath their feet, carrying it out in wheelbarrows. Near Netherton and elsewhere they could pick up the seam and follow it into the hillside, at times for a distance of a hundred yards or so. In these cases there was no need for a pit to be sunk: the coal seam might remain at the same contour for some distance into the hill, so enabling the colliers to dig for a long while without going down at all.

When at last true mining became necessary, the thick coal provided as many dangers as blessings. Its very thickness made for difficulties. Large pillars of coal had to be left standing so that the roof would not cave in. The coal crumbled very easily, and as it was easier to sell large lumps than small ones, the slack and rubble stayed below ground: it simply was not worth bringing it to the surface. But of course, slack burns very easily, and here was a ready made fuel for any conflagration below ground to devour. Hence many mines were made useless through the outbreak of "wild-fire"; Plot mentions an area of eleven acres of burning wild-fire in Wednesbury at the time of his visit.

In the mid-seventeenth century the first signs were becoming visible of the Black Country developing into an area wasted by mining and quarrying. Already the woods had been felled; now the devastation proceeded below ground, beginning to produce ugly banks of spoil and rubbish which it was nobody's business to tidy up. The roads became worn and rutted, arid wagons were replaced as a means of transport by the packhorse train. Thirty or forty horses would lumber along the muddy or dusty roads one behind the other, each carrying two hundredweights of coal. In front was the carrier with his warning bell, so that one avoided the train. It was certainly impossible to pass.

Where the wild-fire burnt beneath the surface, fumes and smoke rose through the rock above and sulphur deposits were left on top of the ground. The rocks themselves were calcined into what was called "shattery", a porcelain-like substance. If the underground heat was exceptionally intense a hard, fused rock was created. The landscape began to look like a smouldering volcano in the neighbourhood of the mining areas, especially at Wednesbury.

Deaths in the mines became more frequent. At the best of times a miner's life was dangerous. There were deaths and maimings from roof-falls, from falling down shafts, from suffocation by gases, by explosions and floods, the last of which was a very common cause of wastage, both in human lives and pits. Once the mines became flooded it was very hard to drain them, and methods of prevention were primitive. They were sometimes drained by a "sough" or ditch which was dug along the side of the coal

and was supposed to take away the water to a point where it could be safely diverted downhill towards a brook, destined to become black with coal dust. Alternatively, water could be brought ip to the surface in wholly inadequate receptacles and poured away. This was rather like bailing out an ocean liner with a sauce-pan.

The coal itself is described with lyrical intensity by Dr Plot. Writing of the coal in the Bilston neighbourhood he says:

> ... it is a flat, shining coal, having pretty open grain, lying seldom in a level with a plane of the horizon, but most times inclining somewhat to it (according to which if cleaves into blocks at the discretion of the workmen) that burns away with a clear bright flame, and into white ashes, leaving no cinder as that from Newcastle-onTyne ... I was told by Mr Pursehouse that in his grounds at Ettingshall, at a place called Moorfields, the bed of coal is fourteen yards thick, inasmuch that some acres of the ground have sold for £100 per acre! I was informed of one which sold for £150, and well indeed it might be so, for out of a single shaft there has sometimes been drawn £500 worth of coal.

On 31st July 1671, there was born in Wolverhampton one of the most famous (or to the Irish infamous) sons of the Black Country. William Wood, later to introduce into Ireland a flow of brass coinage which the Irish did not want, was the son of Francis Wood, silkweaver, and Mary Granger, who came from a family of bellows-makers. He married Margaret Molyneux of Willenhall, daughter of John Molyneux, also a metal worker.

Young William prospered; his marriage took place in 1690, and he soon owned copper and iron works in the west of England. One after another, fifteen children were born to him and baptized in Wolverhampton. The family lived at the Deanery, a pleasant mansion which fronted on to what is now Wulfruna Street. Even though eventually William Wood went to live at Hampstead in London he did not dispose of the old house, but rented it out, continuing to take an interest in it.

One of Wood's specialities was the manufacture of coinage for places abroad, which was not always well received by the overseas territory concerned. When in 1722 he produced coins for North America the Americans protested. Then, later in the same year, he was granted a Royal Patent to supply coinage for Ireland during the next fourteen years. Though the Irish had their own parliament, they had not been consulted. They objected both because they had wished to mint their own coins, and because Wood's coins were made of base metal, and were not worth their face value. When constitutional protest failed, Dean Swift, a man mightier with the pen than Wood with his money, began to write a stream of tracts

on the topic. Best known were the *Drapier's Letters* in which William Wood was called "this little impudent hardware man".

But the hardware man, backed by Walpole's government, did not drop his plans. The Irish claimed that the quality of the coins was inferior, but Sir Isaac Newton gave his verdict in favour of the coins. The Irish protested with redoubled vigour, and Swift added to the stream of petitions, pamphlets and ballads by publishing his "Serious Poem upon William Wood, Brasier, Tinker, Hardwareman, Coiner, Counterfeiter, Founder and Esquire". A solemn procession marched through Dublin escorting the effigy of the Wolverhampton ironmonger to a public hanging. After the "hanging" the "body" was cut down and burnt with great pomp to the delight of a vast crowd.

By strange chance John Molyneux, Wood's brother-in-law, had set up in business as an ironmonger in Meath Street, Dublin, and when this connection was known, he might well have suffered the fate in reality that Wood suffered in effigy. He advertised that he had no connection with Wood and: "We (John Molyneux and his half-brother Daniel) never were possessed of any of the said Halfpence or Farthings, except one Halfpenny and one Farthing, which I the said John Molyneux received in a post letter, and which I immediately afterwards delivered to one of the lords Justices of Ireland."

Swift's *Drapier's Letters* were indicted as seditious, but successive Grand Juries were unable to agree to the charge and by the end of 1724

21. Great Bridge

the case against Wood seemed won. By the middle of the next year he had surrendered his patent, bowing to the will of the Irish people and the barbed satire of Jonathan Swift. William Wood had thus been the direct cause of Swift's emergence in the role of Irish patriot during the time of his greatest activity, the time when *Gulliver's Travels* itself was becoming crystallized in Swift's mind. The case of "Wood's Halfpence" remains notorious as an example of England's tactlessness with her subjects and allies.

As for the cause of all this furore, he continued to prosper in finance, but declined in health. He died in London, but was brought back to Wolverhampton for burial on 6th August 1730. His eldest son William then took charge of his multifarious enterprises, which were at one time carried on in thirty-nine counties. Among the work of the younger William Wood were the iron railings at St Paul's in London, made of Sussex iron.

Iron-smelting, nail-making, coal-mining, financial juggling: they were all part of the Black Countryman's occupations during the Stuart period, and we should not forget the smaller trades such as pottery, clay-pipe making, saddlers' ironmongery (forerunner of the Walsall leather trade) and brickmaking, which all developed at this time. The last mentioned was on a very local scale, and the finished bricks were used to build houses and other buildings of "Queen Anne" style, certainly a very neat and pleasing kind of design. Wolverhampton, Dudley and Halesowen are among

22. Ruiton Windmill

places where traces of this architectural style remain or have remained until recently. The presence of brick-kilns in various towns and villages is indicated by field names which survived into the nineteenth century.

Dr Plot makes mention of quarrying in various parts of the Black Country for stones other than the all-important ironstone. Bilston sandstone was very fine grained, and could be used to "keen" knives, scissors and even razors. Similar stone was to be found at Sedgley, near Cotwall End. In 1591, when Richard Jones died at Rowley Regis, he was owed for "nineteen blowe stone and two half-loads". Presumably this refers to Rowley ragstone or dolerite, the hard volcanic rock which was evidently being quarried already for building, and also for stone-walling on the hills. A number of houses built of this intractable material have not long ago been demolished, among them a farm in Siviters Lane dated 1663. Quarries at Gornal were producing hard stone suitable for millstones, while houses and barns at Sedgley, Dudley and Gornal often used stone instead of brick for their construction.

Despite all this industrial activity, it must not be thought that the Black Country at this period yet deserved its later name. The majority of the people still lived mainly by agriculture, and even in towns such as Wolverhampton and Walsall farm animals were a constant sight in the streets. Even though the wild-fire at Wednesbury blackened the grass and destroyed all chance of cropping, most areas were green with well-tended meadowland, pasture and woodland. Small farms dotted the scene, merging now and then into groups where a church tower betokened a village or a high gable denoted a manor house. Trunk roads, which were later to cause re-siting of villages such as West Bromwich and Handsworth, were very few, and on the whole not many people left the area or migrated to it. The population grew steadily but not excessively. All seemed set for a fairly prosperous rural future in spite of the rather indifferent soils; there was still no outward reason to imagine that by the end of the next century a dark polluting stain would have the region firmly in its grip.

A FEW SMALL SPIRES

In the softly undulating country of the Midlands the early eighteenth century was a period of calm before storm. Life combined lazy tradition and classical taste, the rich county families cultivating the latter and the poorer classes moving unperturbed along the time-rutted ways of the former. In every part of England there was a deep contentment with country ways which began to impress artists and literary people. Poets had read the Latin writers Virgil and Horace, and when they saw how affected these men had been by the Italian landscape of the first century BC, English writers realized the value of the pleasant land which surrounded them.

The Black Country produced an odd selection of poets in the eighteenth century. The most famous and talented was William Shenstone of Halesowen, who was born at The Leasowes in 1714. Looking at his portrait in the National Portrait Gallery, one sees the usual rather corpulent eighteenth-century figure, dressed in cloak, long coat and breeches, buckled shoes, with a scroll in his hand and a wig on his head. He leans rather affectedly upon a marble stone, perhaps a tomb, and behind him, through a portico, can be seen a country landscape, undoubtedly English. The whole poise and balance of the picture is relaxed, but perhaps too artificial.

Shenstone developed a passion for books while still a small boy, though there was nothing in his parentage which might have led to this. His father was a farmer, whose family had come down the hill from Lapal two generations ago and could only be described as "yeomen". His mother's family may have been a little more distinguished: she was born Anne Penn of Hagley, and lived at an old half-timbered house of some note in the neighbourhood. Still, young Shenstone became so enthusiastic about reading that if ever the family went to a market town they had to bring him back a book. If they forgot, his mother had to resort to the deception of wrapping up a piece of wood in paper, which the little boy would take to bed and hug on his pillow, till he fell happily to sleep.

A little later he went to school at the cottage of Sarah Lloyd, village schoolmistress, who instilled elementary grammar and reading into the

SHENSTONE'S BOOKPLATE

23. William Shenstone's bookplate

boy. He described this staunch lady in "The Schoolmistress". When the children, hair carefully brushed and homework at the ready, walked up the path, they had to shoo a collection of foraging hens out of the way before they could reach the door by the old birch tree. Their teacher was a commanding figure; she wore a cap "far whiter than the driven snow" and blue apron, and had a russet stole thrown round her shoulders, made of wool from local sheep, spun and woven by herself. In her hand she carried a twin birch spray from the tree outside, ready to chastize any child who had failed either in appearance or in work. Shenstone's poem shows, with some satire, the high respect in which she was held.

There were many such dame schools in the Midland villages at the time, though, of course, more sophisticated schools existed as well, especially in the towns. Among these the most notable was probably that founded by Queen Mary at Walsall; but the early eighteenth century was not a peak in the performance of these schools, and many were small and backward. Still, we do hear of new grammar schools being founded at this time, such as the school at Aldridge, for which land was given by Rev Thomas

Cooper in 1718. The Lord of the Manor also gave land which was about to be enclosed, thirty local men subscribed money, and a trust was founded to see that the pupils should be taught the Catechism, Latin and English language, and written English.

The best known grammar school for miles was at Solihull on the other side of Birmingham. Here a Mr Crumpton taught Shenstone Latin and Greek, basing his teaching on the elements instilled by Sarah Lloyd, and raising the budding poet to a high degree of competence in these two languages, which he began to love very much. Shenstone met a good many people here of the yeoman class, sons of clergymen and small landowners. He was fond of wandering through the Warwickshire countryside with them, books in hand, quoting reams of verse from earlier poets. Certainly he was a strangely impractical and romantic son of Halesowen!

After coming down from Oxford, where he met many other young poets, he went to live at his mother's old house near Hagley. Here he led a rather aimless life. It was not that he frittered away his time in cards or dancing: these pursuits he said were only fit for children and savages respectively. He continued to read a great deal, and was by this time busily writing his own verse, trying to overcome a problem which must have been very acute for some eighteenth-century writers who were not real masters of their

24. Plan of The Leasowes

art: "Nothing," he said, "makes so awkward a figure in verse as sincerity:" Despite this, Shenstone did manage to be sincere and charming, as in this passage from "The Pastoral Ballad":

> I have found out a gift for my fair
> I have found where the woodpigeons breed:
> But let me from plunder forbear,
> She will say 'twas a barbarous deed.
> For he ne'er could be true, she averred,
> Who could rob a poor bird of its young;
> And I loved her the more when I heard
> Such tenderness fall from her tongue.

About 1744 Shenstone began to be very interested in the new fashion of landscape gardening. The grounds at The Leasowes were very suitable for this, as one can still see today. At this point the ridge falls sharply away from Quinton towards the Stour valley, so that the house itself nestles into the hillside very picturesquely. The view from the house takes in the Clent hills, and on a clear day extends far into Shropshire. At the foot of the hill is a cluster of factories with tall chimneys which Shenstone would have deplored, but apart from this there is not much industry to be seen in the landscape.

When he took up residence there, his first act was to cut a path through the woodlands and scoop out an existing marl-pit into a little romantic grotto. In this he built his "hermitage", nailing a wooden cross over the door. He fabricated a strange "ruinated priory", using stone from the ruins of Halesowen Abbey, only a mile or so away, and built a summer house over a clear pool round which beautiful beech trees clustered. The little streams which ran down to join the Stour already fell steeply, and not a great deal of effort was needed to produce waterfalls here and there along their route, which can still be seen. Dotted about were seats and urns inscribed with the names of Shenstone's friends. All this may seem rather a radical interference with the natural landscape, yet Shenstone's friend Robert Dodsley wrote:

> Far from violating its natural beauties Mr Shenstone's only study was to give them their full effect ... The hand of art is in no way visible either in the shape of ground the disposition of trees or the romantic fall of his cascades.

In all these enterprises he had the backing and interest of the Lyttletons of Hagley, who brought other great men with them to see The Leasowes.

Among these was William Pitt, later Earl of Chatham, who found the grounds most pleasing. Shenstone acquired a reputation for knowledge about landscaping, and was called upon to advise, among others, Lord Ward of Himley Hall, heir to the Dudley estates, and Lord Foley, descendant of the celebrated Fiddler Foley mentioned in the previous chapter. He mixed apparently on equal terms with these members of the nobility, though he couldn't follow them in lavishness of expenditure. Not surprisingly, he fell into debt, which. made him very wretched. Amid all his interest in classical taste and his obvious happiness at being on such close terms with rich neighbours, he had a strong feeling for the life of ordinary people, as his poem on Sarah Lloyd shows. He even showed a characteristic Black Country fondness for the poacher, according to a story he told towards the end of his life.

One night in Autumn a poor man from Halesowen, whose usual trade was carrying newspapers about the country, went to Shenstone's fishponds and poached some fish, banging them against tree stumps to kill them. He was caught in the act, and Shenstone felt a wave of anger against a person who could do such wanton damage. However, he enquired into the man's position, and when told about his wife and five children refused to send him to the magistrates.

> I verily believe he spoke the truth, [said Shenstone]. I cannot be so severe against these petty misdemeanours as many are. Nor can I, though I revere the call of justice, be a rigorous supporter of its claims, except in atrocious cases.

He doubted whether the imprisoning of the man for many days was warranted by the crime, and in any case wanted to know how the family would have been supported while he was in prison. Not surprisingly his friends accused him of "screening a robber from justice", and "giving encouragement to future thefts", but he remained unmoved and let the poacher go. There are many other examples of Shenstone's interest in the poor of the district, and it seems that fame never turned his head, but on the contrary gave him some idea of obligation towards his poorer neighbours as well as the rich ones.

Shenstone was extremely liberal in his view of the criminal but attitudes like this were rare. Even the smallest misdemeanours were usually paid for by a visit to the village stocks. The stocks were made of wood, and had holes cut for the victim's feet; here he was trapped for the day while his friends and enemies watched his disgrace. Stocks had to be replaced from time to time: Bilston had new stocks in 1694 (cost 11s 8d), in 1718 (cost 10s 2d) and in 1764. This disintegration of the stocks was not always due

to fair wear and tear; sometimes the criminal smashed them up, as did for example one Linton of Bilston in 1775. His punishment for this was to receive twenty lashes while tied to the tail of the parish cart.

To watch these punishments was one excitement for the inhabitants of a small town or village; another was to listen to the words of the town or village crier, who was generally also the church beadle. He was a proud man, with his silver-laced hat, wig, smart coat, waistcoat, breeches, stockings and hose, even though he only earned five shillings a quarter for this office. As well as crying news and advertisements around the neighbourhood, he had to watch the children and "other unruly persons" at divine service. Woe betide anyone who nodded off in anticipation of their Sunday dinner! The beadle would give him a sharp tap on the head with his gilt or silver stick, and then resume his walking up and down the aisles in search of any further delinquents.

For the poor, mortality was high from recurrent plagues and fevers. One particularly virulent disease was "ye epidemical distemper" which struck the south Staffordshire area in 1728 and 1729. In Bilston 172 people were buried in those two years, and in Rowley Regis burials jumped from fifty-three in 1721 and 1722 to 113 in 1727, 174 in 1728 and 168 in 1729. The chief symptom of the disease was a chill and fever, which led on to complete collapse, and it attacked young and old alike. There was no idea about correct sanitation or proper measures for avoiding disease. These were still unknown a hundred years later when the great cholera epidemic struck the region.

The cost of dying was not all that high. Coffins at Bilston cost between five shillings and 5s 6d during these years. The corpse was wrapped in a shroud (about three shillings) and a winding sheet. The bearers took up the coffin for what was in many towns and villages quite a considerable journey. In the case of Wolverhampton, all the dead from the chapelries, which had originally been part of St Peter's great parish, still had to make the final journey along muddy ways to the high part of the town for burial in the only consecrated ground. Even when, in 1727, burial grounds were consecrated at Bilston and Willenhall, fees still had to be paid to Wolverhampton church. There were many grasping parsons, such as the "very religious tyrant", Mr Pynson Wilmot, whom Shenstone so disliked at Halesowen.

Our second Black Country poet of the eighteenth century was an odd character indeed, twenty years younger than Shenstone, and a friend of his. James Woodhouse was born at Portway, Rowley Regis, in 1735. His family were yeomen and had farmed the hills at Portway for generations. He was taught the trade of shoemaking as a boy and eked out a poor living from this with occasional school-teaching. He had the habit of walking across

to Halesowen to talk to Shenstone, who used to lend him books of all
sorts. An elegy he wrote to Shenstone was printed at Shenstone's request
in the standard edition of his own poems. By this and other means he was
brought to the attention of the London public who delighted in him as a
curiosity-"the shoemaker poet". Dr Johnson, himself a Midlander, knew
Shenstone and gradually came to respect him. But he dismissed Woodhouse
with the comment, "He may make an excellent shoemaker, but can never
make a good poet." Perhaps rustic poetry was outside Johnson's interest
or comprehension, just as landscape gardening was. It was neatly said of
him at the time:

> Bred up in Birmingham, in Lichfield born,
> No wonder rural beauties he should scorn.

Woodhouse was not a brilliant poet, and he lived a long life. The result
is that his works run into thousands of mediocre lines, many of them
autobiographical. His London popularity is evidence of the growing
nostalgia in the city for country ways. Woodhouse pleased the nobility
by his glowing references to such people as Lord Ward of Himley, Lord
Lyttleton of Hagley, and Lord Dartmouth of West Bromwich. Here is a
small section of his work describing (without much visual impact) the
Black Country scene as the sun sets.

> His evening legacies of light imparts
> To crowded schools of Industry and Arts.
> Exhibits bustling Birmingham to sight
> In multiplying streets and villas bright–
> Delineates, rear'd aloft, in russet hue
> Barr-beacon's barren heights, in obvious view–
> Shows Wednesbury's and Walsall's blazing spires
> Like metals, fused, before the melting ~res;
> And Wolverhampton's turrets, fair, unfold
> Near Northern boundaries! tipt with burnished gold.

The taste for writing classically styled verse was also indulged by the third
of our trio of eighteenth-century poets, Thomas Moss. He was born at or
near Wolverhampton about five years after James Woodhouse, but was a
very different man. He attended first Wolverhampton Grammar School,
then Emmanuel College at Cambridge, and gained his B.A. with high
honour. When he came down from Cambridge he was made perpetual
curate (he called himself minister) of the newly built church at Brierley
Hill. This was a classical, rather chapel-like building, which had had to be

25. Brierley Hill Church

built to accommodate the increasing population of this part of Pensnett Chase, which was by now becoming scrubby and broken up by growing hamlets such as Brockmoor, Bromley and the Thorns.

Only one piece of the Rev Moss's verse has left an echo in literature, and that is a sad little poem called "The Beggar" or "Beggar's Petition", which he composed at Cambridge. This was taken up by the Gentleman's Magazine, and in 1828 an engraving was printed which showed the beggar standing miserably beside the door of a small house asking for alms. The engraving became very popular and later adorned the walls of many Victorian drawing rooms, while the poem which told of the beggar's sorrows became a standard work for recitation by small children. It is mentioned by Jane Austen in *Northanger Abbey*, where Catherine Morland, the heroine, took three months to learn it. A "printed calico" version of the poem is mentioned by Charles Dickens in *Nicholas Nickleby*.

"Pity the sorrows of a poor old man" the poem begins, and indeed the lot of the poor man was very hard in the early eighteenth century. The workhouse frowned over the prospects of the unsuccessful, the chronic sick and the widowed. During the first twenty years or so of the century workhouses were being adapted from existing buildings by the partitioning off of the side-wings or the rebuilding of walls. At Bilston Mr John Woolley decided to let the poor have a building of "two roomes, a lower and an upper" for the rent of forty shillings to be paid by the poor-overseer. He had already planted the garden, and required "satisfaction for digging and setting", but had still to thatch the roof. This building apparently adjoined

26. Eighteenth-century houses at Bilston

his own dwelling and public house and it is hard to see that the poor could
have been very comfortably off in two rooms even though we don't know
how many poor people would be supposed to live in this building. The
sorrows of a poor old man might well be considerable.

Nevertheless, the housing of the poor in any condition was an advance,
and considering how people disliked paying poor rates, many overseers
did a conscientious job. In another respect some feeling for the comfort
of ordinary people began to be shown about this time. Until recently,
there had not been much church building done since the Middle Ages,
and the parish boundaries had in most cases been fixed before Domesday.
Some of them were very large, and it must have taken the inhabitants
all day to travel from outlying hamlets to divine service on a Sunday as
they were bound to do. Far from being a day of rest, Sunday was a day
of footslogging weariness for all but the rich who could call out their
coachmen and harness the sleekly brushed horses. Even these rich people
may have had doubts in wet weather about the need for such awkward
journeys. Residents of Tividale, for example, faced a steep climb over the

brow of Turner's Hill and down the other side for a mile or so before they met their fellow parishioners at Rowley church who had slogged an equally hard road up the other side of the hill from Cradley Heath and Old Hill. In their case nothing was done; there was no kindly benefactor or determined agitator to move the heavens in quest of a new chapel.

As we have seen, the people of Brierley Hill were luckier, and so were the inhabitants of an insignificant hamlet on the road from Oldbury to Birmingham, called Smethwick. This desolate spot, surrounded on three sides by woods, had slumbered very peacefully since the Norman conquest, subsisting on poor farming and the usual trade of nailing. Every Sunday, and at christenings, weddings and funerals, the people of the hamlet spent a muddy and dangerous hour or so, walking to the parish church at Harborne through the Bear Wood and the Lord's Wood, which gave sanctuary to outcasts from Birmingham and other petty criminals. When they reached the end of their journey there was little more to be seen at Harborne than in their own hamlet – an old clock tower, a farm, a parsonage and deep woods surrounding the little settlement.

Miss Dorothy Parkes, a local yeoman's daughter, was determined to do something about this. She was a serious minded young lady, as one can see from her portraits, and she obviously considered that if Smethwick

27. Smethwick: Dorothy Parkes' Chapel

did not soon have its own church the village would collapse into a state of godlessness: there was no Nonconformist chapel here as in many other local places. So Miss Parkes gave Smethwick its first lead towards independence by presenting the authorities with enough money and land to build and endow a handsome brick church with tastefully executed ornamentation in stone, and a carefully proportioned classical tower. The church was in use by 1732, but Dorothy Parkes had unfortunately died in the meantime and was buried in Harborne churchyard. When her own creation was finished her body was removed and reinterred in the graveyard of the church she had endowed. She was the founder, if anyone was, of modem Smethwick.

The new Smethwick chapel was a further essay in the adaptation of classical taste to the eighteenth-century English countryside, just as was Shenstone's introduction of :urns, groves and ornamental seats at The Leasowes. There were a number of these handsome brick churches built about this time, as for example at Wednesfield (1746), Penn (1765), St Thomas', Stourbridge (1726) – where 61,500 bricks were needed at 2s 6d per thousand – and St Edmund's, Dudley, where the architect may have been Thomas Archer, designer of St Philip's Church in Birmingham. They are not exciting churches to look at, but they mirror the current feelings about decency, reason and utility, so that they are excellent monuments of their period.

There was one showpiece church built in the Black Country during this time, which possesses a particularly beautiful and famous organ: St John's church at Wolverhampton. But at the time local inhabitants could be forgiven for thinking it would never be finished. One morning in 1758 the cry rang through the streets of the town, "Fire! Fire!" There was hardly any need to shout the warning cry, for everyone could see that the almost finished tower of the new church was blazing merrily. The shell of the church had been made of bricks and the cladding of stone from Perton near Tettenhall was almost complete. Inside the wooden wainscot for pews had been finished. But when the workmen had gone home the previous night they had left a brazier alight in the tower, "well-secured, as they imagined". By the time the fire was put out it had done damage to the nave and roof which was certainly great, one estimate putting it at seven or eight thousand pounds.

Wolverhampton pride very soon stepped in to restore the damage, however, and the authorities were able to open the church in mid-1760. It was still not quite complete for it needed a bell, which was bought from St Martin's Birmingham for £35 1s 8d, and some church plate. The organ was bought in 1762 for £500. It was not a new one, but had been built by the well-known organ builder Renatus Harris between 1682 and 1684. It was

28. A worn milestone from turnpike days

built, as the result of a competition, for the Temple Church in London, and the competition, between Harris and Bernard Schmidt, was so fierce that it became known as "the Battle of Organs". Among the famous composers who tested the organs were John Blow and Henry Purcell. At the end of four years' competition the verdict was given in favour of Schmidt's organ, and Harris sold his to Christ Church, Dublin. The beautiful instrument remained in Dublin until 1750 when one John Byfield removed it, and it was his widow who sold it to St John's in 1762.

After these new churches had been built villagers were saved many local journeys along miry and rutted roads on Sundays. But the commercial life of the area, as of everywhere else in Britain, was being strained by the type of highway then available for coaches and other horse-drawn traffic. In the mid-seventeenth century the first Turnpike Act bad been passed, but by 1706 so little progress had been made that it was decided to set up special bodies of local residents to administer these turnpike roads, called Turnpike Trustees. These set up toll gates along their newly laid stretches of road, to recoup the cost of building and repair.

One of the earliest roads to be turnpiked in this way was the route from Birmingham through Handsworth to West Bromwich and Bilston, part of an old route through the Midlands to Shrewsbury. Though there was some doubt at times whether this route was better than the one through Bridgnorth, by 1752 the Shrewsbury coach was routed through West Bromwich instead of by Watling Street and Brownhills, and the growth

Cinder Bank Gate

Frees Wilkes Fold, Old Hill, Netherton. Grange, Coombes, Cinder Bank, and Manor Lane gates and bars.

day Mo. 187

Produce the ticket or pay the toll.

Bumble Hole Gate,

Frees Tansley Hill, Dixon's Green, Tipperty Green, & Long Lane Gates & Bars.

day Mo 186

Produce the Ticket or Pay the Toll.

29. Turnpike gate tickets

of the route caused a shift in the centre of gravity of local towns. Both Handsworth and West Bromwich developed quickly along the line of the road, abandoning their old parish churches well to the north. To take a four horse carriage through a gate cost 2d, and a horse not drawing a coach cost ½d; on other local roads a coach could cost anything up to a shilling.

In the Walsall area, the land was very marshy and there were only a few places where two carts could pass. It must have been a shocking task to travel anywhere at all in winter, when carriages would get stuck in mud and sometimes overturn, tipping their occupants out on to the roads to face the ridicule of passers-by, or worse, the attack of footpads. In 1748 the inhabitants of Walsall had a Turnpike Act passed which enabled improvements to be made to the road to Barr Beacon, the Wolverhampton road, and part of the Birmingham road. Although the act was in force for

twenty-one years, not much was done during the time, and a further act had to be passed. Even so, the toll gates did not pay for the upkeep of all the main roads, and they were a considerable charge on the ratepayers. Despite this they were thought of as a great improvement and people worked hard for them. As he grew older Shenstone, who found his commitments increasing, still busied himself with "joint endeavours" for a new turnpike road from Birmingham to Stourbridge.

Development in all things at this time was slow, however. There was nothing so shockingly new as to turn the heads of the rural population, or make them realize the extent of the changes that would be brought by the industrial revolution now just around the corner. Offenders provided some excitement by being beaten or put in the stocks; in quiet rectories and vicarages the clergy were making entries in parish registers like this one by Richard Ames of Bilston:

> June 20th 1715, being Monday, between the hours of three and four in the afternoon, very great quantities of hail and rain – accompanied by lightning and thunder – fell in the constablewick of Bilston. The hailstones were of unusual size and bigness; it was said that some of them were seven inches about, and one was five inches in compass. The hailstones were of the consistence of ice, and in this place it was not doubted that to corn and other tillage it did great damage to the value of

30. Vernacular housing, now a pub: Hill Top

£900, and such prodigious quantities of water were in the streets that the oldest man never saw the like.

Nothing much happened during the year except the seasonal festivals, or such annual ceremonies as Beating the Parish Bounds. At Wednesbury the beadle, perhaps dressed like his Bilston colleague mentioned earlier, led a procession of parish officials off from the Elephant and Castle round the outer edges of the parish, stopping at Tame Bridge. Here a couple of boys were thrown into the stream as a token sacrifice to the ancient river god (though of this origin of the custom the beadle and his retinue were ignorant), and then the procession formed up again and walked back to High Bullen where everyone had a good meal, and the wet and dripping lads were given a pint of beer and some bread and cheese.

In his higher position on the social ladder, the poet Shenstone enjoyed slightly more sophisticated pleasures. In his letters he shows himself appreciative of music-making at Worcester, assemblies at Hagley Hall, small concerts in Birmingham or singing and reading entertainments such as the one which Thomas Hull the actor, with two actresses to help, organized at Stourbridge in 1761. It was, as he says, a "small plan, but to a very commendable purpose ... The profits are devoted to the assistance of a tradesman who had suffered under repeated misfortunes."

Shenstone's life closed on a note similar to that of his earliest memories. The man who as a little boy had been thrilled by a book he couldn't read but snuggled up to in bed at night wrote his last letter to a friend on 16th January 1763, in which he says "the frost is too severe for me to use exercise, and I am quite pampered with snipes and fieldfares. At the same time my mind starves, and I hunger more for a sixpenny pamphlet than I do for the freshest barrel of oysters." Less than a month later he was dead, and his memorial (a classical urn, of course) is to be seen in Halesowen church. So ended the life of a retiring poet and gardener, and so ended a pastoral chapter in Black Country history. Part of his Elegy XV will serve as his epitaph:

A few small spires, to Gothic fancy fair,
Amid the shades emerging, struck the view;
'Twas here his youth respir'd its earliest air;
'Twas here his age breath'd out its last adieu.

EIGHTEENTH-CENTURY RELIGION AND INDUSTRY

As we have seen, during the first part of the eighteenth century new churches had been built at Stourbridge, Smethwick, Wolverhampton and other places. But this new building represented only a drop in an ocean of need. As the century wore on, population grew steadily, without much provision being made in terms of amenities. The Church of England was deeply asleep, having weathered the storms of the last century and arrived as the undisputed guardian of establishment souls. John Wesley's Methodists tried to fill the spiritual vacuum, though the evangelist himself had met with a riotous reception, notably in Wednesbury and Walsall.

When Wesley had first visited Wednesbury, twenty years before the death of the poet Shenstone, he had been welcome and had been allowed to preach there with the support of the Wednesbury parson. But when he returned later that same year of 1743 there was trouble. Crowds from Darlaston chanted the slogan "Church and King" and attacked Wesley's followers. They remained undeterred and continued to meet. Wesley returned to the area again in October, and stayed at the house of a man called Francis Ward in Wednesbury.

Once again a mob arrived from Darlaston, and this time they clustered round Ward's house chanting "Bring out the minister". Wesley was, as usual, very ready to talk. The leaders of the crowd were shown into the house and promised him a fair hearing if he went outside. So he walked out to them and asked what they wanted. They demanded that he should go with them to Bentley Hall and give himself up to the magistrate, Mr Lane. Wesley agreed to go, although it was pouring with rain and becoming dark.

On the way to Bentley it seemed as though the Darlaston men were getting to like the preacher, and some were agreeing wholeheartedly with what he said. As they approached the hall a few men ran on ahead to tell Mr Lane who was coming. These leaders still hoped the magistrates would imprison Wesley for rabble-rousing, in accordance with the terms of an advertisement they had issued. But Mr Lane changed his mind when he

heard that John Wesley was actually being brought up the drive. Saying, "What have I to do with Mr Wesley?" the magistrate retired to bed.

A few minutes later the main body of the crowd marched up to Mr Lane's front door with Wesley amongst them. Lane's son met them and announced that his father was too ill and tired to speak to them. The spokesmen were very surprised at all this, since they had expected a handsome reward. But the only precise allegation which they had against him was that he woke them up too early with hymn singing and continued all day. When he heard this, the younger Mr Lane sent them on their way.

The crowd then went on to Reynolds Hall in Walsall to see Mr Persehouse, who had also signed the advertisement concerning Methodist preachers. The rain was still teeming down when they reached the hall and Mr Persehouse had also retired for the night. Some of the crowd had joined in singing hymns with the man they were supposed to be arresting, and it looked as though the matter would be allowed to drop. At this moment another mob, this time from Walsall, closed in and drove Wesley up the hill towards the High Cross, shouting, "Knock his brains out! Kill him at once." Although he had been hustled from town to town all evening, Wesley somehow found breath enough to preach to the crowd.

The next part of the action took place in Walsall High Street, and moved on to the bridge. Walsall was already noted for saddlers' ironmongery and to a lesser degree leather goods, but it was still a small country town. Near the bridge marshes fringed the brook, which on this evening was in spate, and the old malt mill stood gaunt against the skyline. There may have been rush lights in some cottages, but this was many years before the era of cheerful street lights after dark. There was therefore little light to guide Wesley as he blundered down the street with his books and papers under his arm. The crowd continued to follow him, jeering and trying to trip him up. He knocked at a cottage door, hoping for sanctuary there, but this was refused: probably the inhabitants were afraid that their house would be pulled down around them if they sheltered him.

Wesley turned on the doorstep and tried to talk to the crowd. But before he could begin the mob overwhelmed him and swept him towards the mill dam, surging, pushing and jostling, all trying to be near at hand when John Wesley was thrown from the parapet of the old stone bridge into the swollen waters below. As they reached the bridge, however, there was a pause. Nobody wanted to be the first to push Wesley in. Suddenly Wesley found his voice, and could be heard praying; the crowd became hushed.

The Mayor of Walsall now stepped up and made a speech asking for safe-conduct for Wesley and urging the members of the crowd to go back to their homes. For a while this speech seemed to have the desired effect. The crowd parted and Wesley was able to walk along the path towards

the bridge with four of his followers. But soon the former mood returned, and this time the preacher would have been thrown into the brook if an ex-collier had not picked him up, hoisted him on to his shoulders, and marched off with him to safety. The rescuer was a prize-fighter who had been so impressed by the minister's courage during the long running battle that he took him shoulder-high all the way to Wednesbury.

Rioting and disturbances, some of them organized by establishment figures, attended Wesley's appearances during the first few years of his ministry. Within a short time, however, the Methodists had gained a quiet hearing and Wednesbury became a Methodist stronghold. Wesley fought for nearly half a century to renew the Church of England without leaving it, but in 1784 he had to admit defeat on this particular count, and finally broke with the Established Church. He did not revisit Walsall for many years after his rough handling in the early 1740s, and of Wolverhampton he said: "Such a number of wildmen I have seldom seen." This was in 1761; he later preached on High Green (Queen Square) several times, and eventually Wolverhampton like other local towns became a centre of Methodism.

Among other early Methodist outposts were Cotterell's Farm, Toll End, Tipton; Temple Street, Bilston; Bullocks Fold at Bloxwich; and King

31. Ebenezer Chapel, Dudley

Street, Dudley. A close friend of Wesley's was the Earl of Dartmouth, who lived at Sandwell Park. When he went to a meeting at the foot of the so-called "horse block" in Wednesbury, he used to allow himself to be addressed as "Brother Dartmouth", though anywhere else he was very strictly on his dignity. Wesley wrote to him in 1764:

> At present I do not want you but I really think you want me. For have you a person in all England who speaks to your Lordship so plain and downright as I do, who considers not the Peer but the man, not the Earl but the immortal spirit?

Although Wesley visited Cradley, preaching there in 1770 with the north wind whistling round his head, he was not in fact thrown in Hayseech brook, as the local rhyme says:

> John Wesley had a bony hoss
> The leanest e'er yo sin.
> They took him down to Haysich brook
> And shoved him yedfust in.

It seems quite likely that the rhyme is a folk memory of the incident on Walsall bridge.

So many of Wesley's contacts with the Black Country were turbulent that it is pleasant to record his happy visits to the mansion at Hilton Park near Bloxwich in 1783, 1785 and 1787, and the cordial relations which existed between Wesley and one Ambrose Foley of Quinton, who having heard the preacher while on a visit to London had built a grotto in the grounds of his farmhouse where the village people met. After some endeavours Foley persuaded John Wesley to visit Quinton in 1781, where he spoke to an attentive audience. As a result a chapel was opened which was the ancestor of today's Quinton Methodist church, staring in its purple brick towards the M5 motorway cutting.

The influence of Methodism and other Nonconformist sects in the Black Country has been enormous. The emphasis placed upon moral endeavour and self-respect had an effect on the characters of countless ordinary working people, and the educative influence of Sunday schools was great throughout the nineteenth century. It is often through the Methodists that the Black Countryman has learned to put forward a rational argument, to speak clearly in public, to hold his own views despite opposition. The Methodist choral tradition is still alive, manifested every year on the one hand in splendid concert performances of the Messiah in Wolverhampton Civic Hall, and on the other in a very lively standard of musicianship in the

32 & 33. Early schooling; New Mill Street, Dudley

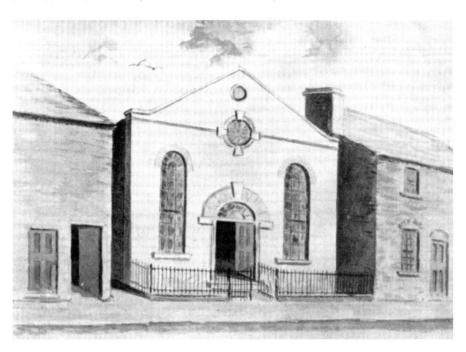

amateur performances of oratorios in chapels and churches up and down the area. In so many ways did the spirit of the tireless preacher overcome the violence of the mindless mobs during the testing years in Darlaston, Walsall and Wednesbury.

By the last part of the eighteenth century there were increasing signs of the Black Country becoming an industrial region. One of the vital factors in this process was the building of the canals, which began to dominate the landscape and were a wonder to everyone. People called them the "silent highways", and they were an immediate boon to the coal traffic, though with the greater availability of coal the price naturally dropped sharply. The first canal through the central part of the Black Country was the Birmingham-Wolverhampton canal, set in motion by a meeting held at the Swan Inn, Birmingham, on 28th January 1767. Its specific purpose was to link the principal coalfields with Birmingham via Smethwick, Oldbury, Tipton Green and Bilston. There was also a branch to Wednesbury which opened first, and on which, on 7th November 1769, the first coal arrived in Birmingham.

William Hutton, the historian of Birmingham, writing a little later, commented about its path through Smethwick that the canal used "six watery steps" to the summit and another six to descend again. These twelve locks proved a great nuisance on such an arterial canal and they were reduced by six in 1789. Telford was called upon in 1825 to straighten out the path Brindley had chosen; in the Smethwick area he made the canal

34. Canals: a lifeline for industry

cutting seventy feet deep, a breathtaking gorge travelling straight as a die through the heart of the town. It is hard not to see grandeur in this gorge and beauty in Telford's fine road bridge which arches over the cutting.

By May 1770 the canal had reached Tipton, and the competition with Wednesbury coal became very fierce. Soon Bilston was reached, and by 1772 the link was made with the Staffs & Worcester canal at Aldersley Junction. On the other side of the Rowley-Sedgley ridge a canal was constructed in 1776 to connect Stourbridge with coal, iron and limestone mines in the Brierley Hill district, and with the Staffs & Worcester canal at Stourton. By 1779 Dudley was connected with Stourbridge via Black Delph, and by 1792 the great tunnel under Dudley Hill was complete. This remarkable canal tunnel, only eight feet six inches wide, passes through a number of limestone caverns in the centre of the hill, in which extraordinary rock formations are found.

These early canal tunnels without towpaths are gloomy affairs. A Victorian guidebook quotes this impression of the Lapal tunnel which carried the Dudley canal's Selly Oak link through the uplands south of Quinton to a place oddly named California:

… There is no towing path. The horses go across the hill and wait for the boat at the other side. And the boat enters the low, gloomy, damp arch alone, the boatman using his long pole and pushing with it against the canal side. But once inside the pole is useless. So he and his companion lie on the top of their boat upon their backs, and push with their feet against the tunnel roof. Push! push! push! push! Slowly, very slowly, laboriously the boat moves on. It is dark, dismal, damp. There seems hardly any air at times while at others the cold draught pierces right through one's clothing. The waters lie silent at times, at others they lap, lap, lap against the boat and the sides of the tunnel. The sound of the leggers' feet against the roof echoes and re-echoes through the darkness. The drip, drip of the water from above keeps up a continuous, unpleasant, unnerving sound. All sorts of undesirable thoughts flash through the brain. Suppose … Or suppose … And still our boatmen push on unconcernedly, talking to themselves now and again, their voices rumbling overhead until the sound is lost in the distance. Then, suddenly, we emerge into the sunlight, and draw a breath of pure, fresh air and look at each others' white, scared faces, and laugh at our fears.

Gradually the canal network spread, bringing every part of the region within reach of safe and comparatively speedy transport of bulk cargoes. And wherever the canal came, industry followed. Coal mines began to open up rapidly alongside the "cut" and the first factories began to be

built near to the Birmingham-Wolverhampton canal. In the dusky waters at night, reflections abounded of fire and steam, mingling with the moon and stars.

The whole landscape was changing during these last years of the eighteenth century. On the heaths, such as Pensnett Chase, the briar and brambles still bloomed and the gorse still made a blaze of gold. Even today there is gorse to be found by the sides of neatly planned housing estates or on the remains of old pit banks. But by 1784, pits, nail shops, 99 small forges and furnaces, brick and lime kilns were dotted in profusion on Pensnett Chase and many other places. Around Brierley Hill alone there were a dozen "whimseys" – pit pumping engines. They spat, they spluttered, they poured steam into the air; they roared and rattled and leaked hot water to provide the local women with tea; and with all the noise they managed to keep the mines somewhat drier than they would otherwise have been, tipping the coal black liquid from below into the new made canals.

New machines brought new dangers to add to those of the coal mines. George Barrs, curate of Rowley Regis, was among a number of parsons who recorded some of these accidents in parish registers. For example, there was Henry Edmunds who "was killed in a coal-pit near Brierley Hill. His clothes were caught by an hook, or something of that kind, of the skep, which took him up a considerable way; at length his clothes tore, and he held on by his hands till being unable to hang on any longer, he fell and spoke no more". In 1801 we read of a "youth, about twelve years of age, who was killed by the swivel bridge over the canal at the Brades", while Betty Auden "drowned herself in the canal near the West end of the tunnel at Gosty Hill. The coroner's inquest sat on the body, and a verdict of lunacy was returned." And in 1810 Thomas Williams "fell into a coal pit in the dark about 8 o'clock on Saturday at Windmill End. It had lain uncovered and unguarded nearly twelve months and was twenty yards deep in water." Man had invented machinery and made deep mines, but could not yet protect himself against the consequences.

The opening of the canals caused a tremendous increase in short distance traffic in the towns nearby. In 1777 an act was passed in the Houses of Parliament to enable the burgesses of Wolverhampton to improve the layout of the town centre. A long list of properties for demolition was appended, including such picturesque but filthy piles as the butchers' shambles (which reeked of ofal and where blood ran down the gutters) and the Market House, a town hall in the style so frequently used in English market towns with space beneath for the market and a room on top for the council to meet. A similar one at Wednesbury was demolished in 1824, and a decision to take down the old market hall at Dudley was reached in 1850.

35. Industries in Wolverhampton

As well as removing old buildings the Wolverhampton town commissioners tendered for lamps, lamp-irons and oil for lighting the streets. Streets had to be named, and the names were written up in clear lettering so that there should be no confusion. Contracts were given to street cleaners, and their job must have been very difficult in such a crowded locality. Though there were no plastic cartons to be dropped, and bus tickets had not been invented, there was enough "muck, dung, or manure" for the commissioners to collect a fair profit a few years later.

By this time, Wolverhampton trades were very diverse. In many ways they resembled those of Birmingham, and in fact there are plenty of examples of migration from one town to another in the course of trade. There were still many lockmakers in Wolverhampton, though the trade was gradually to decline there in favour of Willenhall. The locksmiths pursued their calling in small workshops attached to the rear of their dwellings, or in outhouses in the yard; like the bucklemakers they worked on a family basis, the trade being passed on from father to son.

The late eighteenth century was the age of the "steel toy" maker in Birmingham and Wolverhampton. Before the gold and silver of the New World and Australia came on to the market, precious metals were very scarce and a lot of the jewellery worn by the bourgeois classes was made

36. A village called 'New Invention'

of steel. Steel brooches, studs, sword-hilts and other ornaments were very fashionable. The workmen in this craft were independent, like so many other small manufacturers of the time in the West Midlands. They used equipment that was not too expensive to buy, and could follow their trade in workshops near their dwellings. Some of them were very fine craftsmen: unlike nailing, the work demanded continual exercise of taste and judgment as well as very alert and sober attention.

Two beautiful decorative trades flourished in the Black Country during the eighteenth century. These were japanning and enamelling. The first was introduced from South Wales about 1720. Tinplate ornaments were painted with clear designs and then varnished with lacquer, a process which had originated in Japan. One of the leading Midland japanners was John Baskerville, who deployed his genius for design in such a way that he was said to have "revolutionized" the trade. Baskerville's works were in Birmingham, but japanning was carried out extensively at Bilston and Wolverhampton also. In Wolverhampton the Tudor house known as Old Hall, once the residence of the Leveson family, was taken over and converted to a japanning factory. The workmen had to be good artists, and by the end of the century, japanned caricatures were being turned out, which demanded a steady hand with brush and pencil.

About the middle of the century the japanners discovered papier mâché, and they produced and decorated articles of this material instead of, or in addition to, tinplate. All sorts of articles were made of japanned papier mâché, including trays, letter cabinets, and even small tables and cupboards. The predominant colour of these articles was black, often with a red, green or orange design on it. Flower paintings were much in vogue, and there were also landscapes or local scenes, such as the painting of Birmingham Bull Ring which can be seen in the City Museum and Art Gallery.

Meanwhile enamelling had become well established in Birmingham, Wolverhampton, Bilston and Wednesbury. There was also a factory for it in Battersea, London, and many of the items produced in the Midlands went under the name of Battersea enamels. Enamel ware is produced. by spreading enamel, a kind of coloured glass, in very thin layers on copper or tin plate that has previously been hammered into shape. Patch boxes, snuff boxes, candlesticks and medallions are typical examples of this ware. Very delicate miniatures were produced, specimens of which can be seen at Bilston Museum and Bantock Park Museum, Wolverhampton. There was a curious air of mystery about the trade; the Bilston enamellers worked at night and with their faces muffled as a protection, as so much close work had to be done at high temperatures. It was not surprising that some of the townspeople accused them of being in league with the devil.

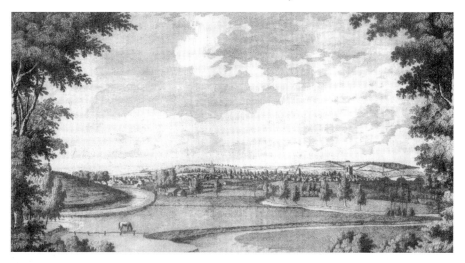

37. Stourbridge in the late eighteenth century

Meanwhile, two linked trades were flourishing in the developing town of Stourbridge, in the extreme south-west of the Black Country. Dr Plot, whom we have already mentioned, had written of some exceptional fire-clay found at Amblecote. This contained a high proportion of silica and alumina, and would not easily crack in a furnace. From the seventeenth century the clay had been sent to glass-making areas all over England, as well as stimulating local trade. About 1615 foreign glass-makers had settled around Stourbridge and had mingled with the native men already making window glass. From then on, glassware of increasing delicacy had been fashioned, and windows had been supplied to builders in all parts of the Midlands and the West Country.

By the end of the eighteenth century the foreign names had disappeared from the list of glass-manufacturers. In 1796 there were eight firms working in Stourbridge, Wordsley, Amblecote and Brettell Lane, and an estimated 520 men employed in the industry. Glass was also being made at several glass-houses in Dudley. It will be obvious from this that glass-making, unlike many of the trades mentioned so far, could not be carried out in small workshops behind the dwelling-houses. Some considerable capital was needed to run it, and a special type of building was needed.

By the beginning of the nineteenth century the cones of glass-houses were landmarks in the glass-making areas. These cones rose from a jumble of smaller buildings, which would include coal and wood stores, probably served by the canal at the rear. Near the bottom of the cones were small windows, but beyond this the bricks of the cone rose one upon another without any aperture to the top, where a cloud of smoke hung, as from

Mockbeggar Hall, Essington. Probably built as lodgings for retired employees of the Vernon family, housing 8 families. Later used as dwellings by miners and became known as Colliers Castle. Built in the late 18th Century, it survived until the mid 20th Century.

38. Essington: Mockbeggar Hall

an ordinary factory chimney. Inside the works, under the towering cone, the centre was a white-hot furnace. This was brick built and contained ten or twelve openings through which the molten glass and flames could be seen.

All round the furnace teams of glass-makers worked. The technical name for the team was a "chair", because the team leader, who did the skilful part of the process, sat for much of his time on a low bench with arm rests. These arm rests projected forward towards the furnace, and across them he placed the rod on which he handled the molten glass while he shaped it. The other adult in the team obtained the glass from the aperture in the furnace, "rough shaping" it as he did so. Two boys completed the team; their jobs were various and included holding the glass with a supplementary rod, and bringing tools. Each team in the glass-house specialized in one particular item-decanters, tumblers, goblets, etc.

In the meantime fireclay production continued on a site not far from the one which Plot had seen in 1686. Clay was hauled out of the pits, where it was located below three coal seams, in great lumps. Teams of women took it, washed it, and sent the outer layers to the copper industry. Some of the best clay was retained for local use, and the rest carried to Stourport, then via Bristol to other places in Britain and to overseas markets.

At about this time there was very considerable enclosure of the remaining heaths, commons and wastes of the Black Country. The Rowley Regis Enclosure Act was passed in 1799, though the award was not made until 1808. Under this act large parts of Blackheath were incorporated as fields into neighbouring farms, but the greatest acreage of land enclosed was at Cradley Heath, where it became the property of the Attwood family, proprietors of Corngreaves Iron Works. There were two waves of enclosure on Pensnett Chase. By 1777 fifteen hundred acres of land in Wall Heath, Wordsley, Brettell Lane, Bromley, Shut End and Kingswinford had been fenced round and added to local farms. The remaining fourteen hundred acres, except for fifty-two acres at Barrow Hill Coppice, were divided among local and other proprietors in 1786. In these enclosures, as in many leases of the time, mineral rights below ground were excepted. Most of them were retained by the Dudley family.

It is said that before enclosure Barr Common supported a total of over 11,000 grey-faced sheep during the summer. The common was described as "a barren sheepwalk, containing in some tracts scarcely any other plant than heath, in other places fern, gorse, whortleberries and rushes with grass in small proportion". In 1795 it was proposed to enclose about 2,000 acres of it and as usual an enclosure act was prepared. The Bill was brought in by Sir Edward Littleton and the Earl of Sutherland, descendant of the Leveson family of Wolverhampton. The Act was quickly passed, only two proprietors having any doubt about the matter, and the awards were completed by 1799. Three years later the remaining commons of West Bromwich – by now a town of nearly six thousand inhabitants-were enclosed. A lot of this land was sold for building plots, the centre of West Bromwich being described as: "All surrounded by the most delightful scenery of Dudley Castle and the Rowley hills."

The problem that had beset Dud Dudley and the other early ironfounders was solved in 1709 when Abraham Darby, who hailed from Sedgley, managed to smelt iron with coal in Shropshire. The process did not become available in the Black Country until the mid-century. But by 1788 there were six blast-furnaces working in the area. One of these was the furnace near Bilston of "iron-mad" Wilkinson, whose interests in the iron industry were country-wide, and who locally had close connections with the firm of Boulton and Watt whose Soho factory on Handsworth Heath contributed to Birmingham's fame as "the toyshop of the world".

The rapid development of steam power led to a decline in the need for the old sources of power, and made it possible to cut the ties which had existed between the rivers-Stour and Tame-and iron manufacture. This resulted in the growth of towns like Tipton, and the decline of Wednesbury, which was being overtaken in that part of the Black Country

by West Bromwich. Home industry, mainly nailing, still occupied a quarter of Tipton's population at the turn of the century, but there were increasing numbers of small furnaces and forges, such as that owned by Zachariah Parkes at Dudley Port. There were also hinge-makers, shovel and tong shops, auger and edge-tool makers and screw manufacturers. Almost anything metal needed for the equipment of an Englishman's house could be made at Tipton in those days.

And what about the "Englishman's house"? What did it look like by now, and how did it come to be built? Who built it, owned it, rented it, lived in it? Not many people owned their own houses, either in town or village. People built houses as a speculation, or at any rate an investment. Take, for example, the Rowley Regis Building Society, inaugurated at a meeting of local people at the Swan Inn, Rowley, in 1794. Here they decided to build a row of houses at right angles to Hawes Lane, near the windmill on one side and Rowley church on the other. Though described here and elsewhere as gentlemen, the members of the building club were really local tradesmen with money at their disposal and an eye to business.

John Mackmillan drew up the plans. He was no architect; building methods in the Black Country were traditional and they simply grew as time went by. However, Mr Mackmillan could wield a pen and measure a space. Jesse Taylor was employed as the builder. It is recorded that he paid eighteen shillings pet thousand for the bricks to be used. As we can see, they were of the small measurement produced at the time, and are a pleasant colour, not too violent in contrast with the Rowley ragstone, of which most of the village buildings were made then.

It was agreed that Jesse Taylor should build four houses, four nailshops and four necessary houses (earth closets) and "plaster them down and seal them and lay the floors according to the plan delivered in a workmanlike manner, and to finish the same by loth June (1795)". Taylor was to be paid £31 10s for this work, but would forfeit £5 if the contract were not finished on time. For the paving slabs, a pavier from Birmingham was hired. Eight houses were ready by 1797 and by 1800 lettings were advanced. The houses were of two storeys, fronting directly on to the "fordrough" leading off Hawes Lane, and had their nailshops at the other end of a small garden.

This was the kind of house chiefly being built at the time, either in rows of ten or a dozen, or in a slightly larger form as detached dwellings. Building styles in the Black Country changed very little in the first part of the next century, and houses built as late as 1860 sometimes still have the small arched windows, the central door, two storeys and lack of front ground. At the same time in Birmingham and Wolverhampton, where pressure on space was greater, three storey buildings were being put up

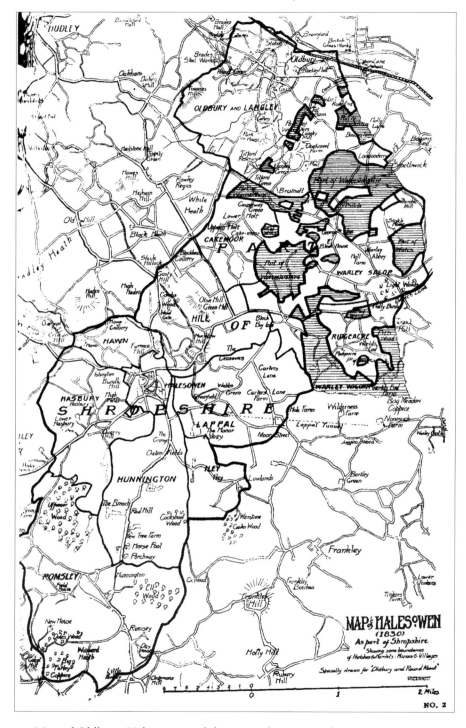

39. Map of Oldbury, Halesowen and district in the nineteenth century

with more elaborate decorative features such as ornamental drip-moulds and lintels, and sometimes decorative pillars supporting the lintel over the front door. Only at Sedgley and Dudley was any other material than brick in frequent use for building houses; here limestone cottages were built, some of which have survived. Sandstone was an occasional building material, as for example at Hasbury on the outskirts of Halesowen.

As well as building societies, "Friendly Societies", formed to help dependants in the event of the illness or death of the breadwinner, grew at this time. It is said that Walsall was particularly provident in this respect, and the rules of Friendly Societies from this and other towns have been preserved. Remembering that the only normal provision for people who fell on hard times was the parish system of poor relief we need not be surprised that workmen thought it well worth while to combine for the purpose of ensuring some future for their dependants, especially where hazardous trades like mining were involved.

In the days before a regular police force, it was necessary to combine to catch criminals. In 1814, for instance, there was formed the Bloxwich Association for the Prosecution of Felons. Under the secretaryship of Titus Somerfield this society offered rewards to anyone who caught a thief and returned the stolen objects and money to their owner. Before this, everyone had to advertise privately, as for example in this notice from Aris's Birmingham Gazette in 1775:

16 August 1775
Whereas William Batton alias Clarke was at the house of William Quinton victualler at Bloxwich on Monday 14th August and left with him a silver watch which is presumed stolen by reasons of the said Batton did the same day abscond from the house of William Quinton being pursued for robbery, whoever can describe the maker's number and other particulars may have the watch again.

SOCIAL AND POLITICAL CHANGE

During the middle of 1832 Asiatic cholera, already rampant in other parts of England, threatened the Black Country. It was to have a marked effect on the reorganization of local government everywhere, since it was only when confronted with an epidemic that officials realized how inadequate the old parish system was becoming. Boards of Health were proposed, which would be independent of the parishes, and would have powers to take action where people were too poor or too ignorant to act for themselves. The powers granted to the Boards of Health foreshadowed those that would later be granted to municipalities when the status of borough was accorded to the large industrial villages, in the Black Country and elsewhere, that had been growing throughout the industrial revolution.

But even the threat of cholera did not move people to action, though they talked a good deal. In every public house, market place, after Sunday service on the chapel steps, wherever people met together, the question most asked was, "Will it visit us, do you think, or will it not?" The Wolverhampton Chronicle listed the symptoms. There would be giddiness in the head, sick stomach, shivering or trembling all over, low pulse, face "as of one dying". Cramp would begin at the toes and fingers and spread all over the body. Some people said the cholera could be halted by the circle of smoke which by now hung over the Black Country, others that the terrifying disease came by water, up navigable rivers from the sea; and the Black Country was far enough from the sea. At Bilston, a public meeting decided that health generally was so good that there was no need for a Board of Health. A suggestion that Tipton wake should be abandoned was not adopted. Then, in July, cholera made its appearance at Rowley Regis.

A meeting of the parish officials was immediately held, which decided to divide the district into small areas, each under the aegis of a volunteer inspector who had to go round and see "in what state the dwellings of the poor are, to recommend whitewashing where it may appear needful and in cases of real poverty to furnish lime and lend a brush". Wise people cleared out "all drains and soughs", kept their families as clean as possible

A PROCESSION OF THE UNEMPLOYED

40. 'The Unemployed' in *The Old Curiosity Shop*

and proceeded with limewashing without delay. These were reasonable precautions; although no one knew it, cholera is transmitted by foul effluent mingling with drinking water, and the spread of the disease was much more rapid in poorly drained areas. Soon, people in Tipton began to fall like flies from the malady, which started with a sharp stomach pain, accompanied by boundless thirst; after this the voice faded out, and the victims crept along croaking a tale of woe to their neighbours. More often than not their neighbours fled in panic. "Healthy" Bilston was the next town to suffer.

During the epidemic it was noticeable that many more people went to church than had done so a few weeks previously. It almost began to look as though the cholera were some old-time visitation of the Lord, and many preachers made capital out of it. The Rev Girdlestone of Sedgley declared that one of the main troubles was drink. Whether a bargain had to be made or a child christened, said Mr Girdlestone, the event was celebrated at the public house. Perhaps the cholera was a direct punishment for drunkards, he suggested, since they fell so readily to it.

In Dudley, notice was given that the two parish churches should not be used to bury cholera victims; everyone dying of the disease must be buried at the new graveyard high on the hill at Netherton. During the long summer evenings Sexton Mackay was to be found with a band of helpers digging vast open graves on the hillside. When darkness fell a clumping sound of muffled cartwheels (the iron tyres silenced by haybounds) banged eerily up the hill; a few subdued instructions were whispered across the ghostly churchyard, and the nameless bodies collected through Dudley and Netherton were tipped unceremoniously into the pits dug for them. There were no coffins, no mourners, no hymns or psalms, no gravestone to mark the spot. Particular horror was expressed one night when a corpse that was just about to be buried sat up; the poor creature had been drowning sorrow in drink and had passed out in a drunken stupor, from which only good fortune had delivered him. Others may not have been so lucky.

Church authorities declared days of fasting and prayer throughout the district, but it is said that at Bilston, the worst hit town, there were not many clergy to be found while the disease raged. St Leonard's Church, the scene of agitated prayer and many deaths, was closed by order of the government, while a quickly organized Board of Health tried to remedy much too late a situation which never should have arisen. Insanitary conditions, overcrowding, poor food, overwork, transient workers – all

41. St Leonard's Church, Bilston: where the cholera outbreak was worst

these had contributed to the virulence of the attack on Bilston, and many of these conditions could have been ameliorated if the authorities had been alert early enough. As it was, curious ideas prevailed on how to get rid of the cholera. Some people gave up vegetables and fish, while many took to brandy and salt in combination, drinking the brandy and poulticing their stomachs with salt. Nevertheless at least 750 citizens of Bilston died, and 404 deaths were reported from Tipton.

Thankfully the cholera declined as winter approached, the last recorded case being at Dudley on 29th November 1832. The disease was only in abeyance, however, for seventeen years later another epidemic struck the Black Country, and though there was much better preparation since the local Boards of Health had been established, the death toll was still considerable. In Wednesbury the 1849 outbreak was worse than in 1832; again common graves were employed, and as many people as possible left the town which became, according to an eye-witness, "as silent as the grave".

Throughout the first half of the nineteenth century the population had been growing enormously, yet the methods of government were still those of rural villages. No one in authority realized the extent to which the Black Country and other industrial areas were becoming urbanized, and that it would no longer do to look at such places as a series of small villages.

42. Wolverhampton in the nineteenth century

Numbers were now too great, and financial interests too much involved, to continue administering the towns by voluntary officials, who simply had not time to do their jobs efficiently and could not beat the lazy ratepayers, often coal owners, at a financial game which was second nature to them.

According to the 1831 census Wolverhampton was the most populous place in South Staffordshire, with nearly 25,000 inhabitants. Over 23,000 lived at Dudley, while the third contender at the top of the list was the diffuse and very mixed parish of Sedgley, which included Coseley, as well as Gornal. 20,577 people lived in this group of towns and villages. Surprisingly enough, the other ancient town of Walsall had fewer inhabitants than either Kingswinford (including Brierley Hill) or West Bromwich which was quickly moving ahead as a new centre of influence. In 1834 there were 107 pubs of one sort or another there, a ratio of one to every 143 members of the population.

This ratio was fairly typical of the Black Country as a whole at this period. This rapidly expanding and hard-drinking population needed lighting home to bed at night, and from 1825 West Bromwich became the centre of a large gas supply industry. At the height of its power, the Birmingham and South Staffordshire Gas Light Company, with headquarters at Swan Village, served an area extending up to Walsall in the north, Sutton Coldfield in the east, Kings Norton in the south and Darlaston in the north-west. These gas lights were never very powerful – ten candle power in 1858 – but by statute the company had to provide a service better and cheaper than could be obtained from oil lamps, or forfeit the right to break up the roads laying gas mains.

Except in the case of the turnpikes, arid perhaps even then, road construction and maintenance was rather a hazardous and inefficient business. Officers were chosen by a meeting of the "vestry", a collection of elected and appointed people, and these officers, entitled "Surveyors of the Highways", had a most difficult and thankless task to perform. They had first to follow out the requirements of the vestry for making new roads, such as the one agreed at Rowley Regis on 29th May 1820, leading from Blackheath to Rowley Village. This was to be twenty-four feet wide, lined with post and rail fence, and have a quickset hedge on either side of it. It was to be made "as straight as conveniently can be done", and to this end the officers had to haggle over strips of land. Thus came into existence the top part of Birmingham Road, Blackheath, and one must agree that a fair job was done in ensuring the road's straightness.

To help them construct and maintain the roads the Rowley Regis roadmakers bought in 1822 the following implements: two iron scrapers; four round pointed shovels; a block with a hollow in the middle and hole for the stones to be driven through; a block and ring for breaking stones,

with a hand hammer and "the letters R. REGIS for a marking iron for the parish". In 1825 their successors handed over to the vestry at the end of their term of office seventeen small stone hammers (several much worn and "all want steeling"), eight shovels (all much worn), one rake, one basket, four wheelbarrows (of which two were at the wheelwrights), one scraper, three mattocks and – but no, they could not find the final item, a large stone hammer which had been left at Mr Beet's (the farmer at Rowley Hall). What had happened to it?

No one really knows the answer to that one, but at least the vestry tried to find out. They questioned one Josh Rose, a poor labourer who had been employed fetching stone from a small quarry on Mr Beet's farm, and he related an evasive story which threw no very virtuous light on Mr Beet. Mr Beet's man, John, said that his master had lent the hammer to someone; and when Mr Rose asked Mr Beet about the matter he replied that "somebody had borrowed the hammer, but he could not tell who". And there is no record anywhere that the large Rowley Regis parish hammer was ever found.

Certainly the roadmenders' job was almost impossible. Local landowners seemed to think they had a right to do all manner of damage to roads lying at the side of their premises. What right had John Attwood of Corngreaves to use Pig Lane, Cradley Heath, as his private sawpit, for example? For this, and for laying down a "dangerous railway" nearby, he was indicted

43. Corngreaves Iron Works

at Stafford assizes. He had apparently made embankments and cuttings in what was supposed to be a public road without even trying to get leave to do so.

Under the threat of cholera and other rabid diseases, and with village life beginning to break down under new economic pressures, the ordinary person of the first half of the nineteenth century sought his pleasures in crude and sometimes violent ways. He liked to see animals baited, and justified this by saying – as some people still do – that animals enjoy the process of battling for their lives. Among the sports that particularly roused the anger of the church authorities were bull, bear and badger baiting, and various societies were formed to stamp them out. As a result a law was passed in 1825 declaring these sports illegal, but it is said the surreptitious meets were held for some time afterwards. There are many streets in the Black Country with the name of Bull Ring or Bull Stake, memorials of those days. A terrifying description of bull baiting is given in Precious Bane by Mary Webb, the Shropshire writer whose characters often seem so like their Black Country neighbours.

When wild beasts could no longer he baited, they were put in cages and trained to do tricks. Wombwell's Wild Beast Show often visited the Black Country, bringing with it a raucous wind band. This uncouth but well practised assembly would play each evening during its visit in the local market place, attracting customers and advertising the fact that the beasts were in the town. Their favourite piece was "The Hallelujah Chorus", and when a Netherton serpent player (the serpent was a very deep wind instrument, a bit like a bassoon) returned from standing in with the band, he announced his pleasure at playing with "the best band in the world".

Wombwell's Wild Beasts were not always well behaved, despite the religious music played by the band. When they visited West Bromwich in 1857, a six-year-old tiger which had been put into a cage next to a lion valued at £300 escaped and fought the lion while the keepers were having their breakfast. It had smashed the barriers which were supposed to keep the lion safe, and when the keepers got back there was nothing they could do but watch the contest. A terrific din was heard all over the town, and when the tiger finally finished off his opponent everyone in West Bromwich wanted to see such a violent and murderous beast. It was subsequently, according to the proprietors, "confined in a cage of extra strength lined throughout with sheet iron".

But this fight was unofficial; more often men were to be seen engaged in prize-fighting. These prize-fighters had nicknames such as "the Gas-light man" – Tom Hickman, whose boastfulness added to the general joy at his downfall when in 1821 he was bested by one Billy Neate. The best known of the fighters was William Perry, the "Tipton Slasher" whose name had

become a legend in the district. Perry had begun as a canal boatman with a taste for fighting, but stepped into the national arena when in 1842 he fought an American stalwart, Charles Freeman, for eighty-four minutes without a decision. The contest was finished later that year after thirty-nine more minutes, and Perry was the loser. Nevertheless he went on to claim the championship in 1850 and was not ousted until 1857.

Early in the 1840s two reports were produced which gave descriptions of Black Country landscape and working conditions. Here is an extract from the Midland Mining Commissioners' report of 1843:

> ... the houses, for the most part, are not arranged in continuous streets, but are interspaced with blazing furnaces, heaps of burning coal in process of coking, piles of ironstone calcining, forges, pit-banks, and engine chimneys; the country being besides intersected with canals, crossing each other at various levels, and the small remaining patches of the surface soil occupied with irregular fields of grass or corn, intermingled with heaps of the refuse of mines or the slag from the blast furnaces. Sometimes the road passes between mounds of refuse from the pits, like a deep cutting on a railway; at others it runs like a causeway, raised some feet above the field on either side, which have subsided by the excavation of the minerals beneath ...

In the same year Mr Horne, a sub-commissioner on the Employment of Children report, walked through Wolverhampton one Sunday to discover what the population did on the Sabbath. He first encountered a group of working men, clad in aprons and caps, with their arms begrimed and their faces smeared from their previous night's work. Their sleeves were rolled up, and they passed by wearily, unconcerned by the fact that it was time for morning service. Mr Horne suggested in his notebook that these might be idlers who had been off work earlier in the week and had stayed late at work on Saturday night to make up the time.

The commissioner next observed small boys fighting in imitation of the prize-fighters. They cursed and swore as blood dripped from their faces. Idly watching them stood their mothers, each woman at the end of an entry or in front of a brown doorway, its doorstep already worn down during the sixty years it had been walked over. Further along, boys were sitting in a hole in the ground using pick-axes to play at mining, while some girls, in rags and without shoes, were playing in elementary dance routines or else just chasing each other. One better dressed group of girls were jumping from mounds of dirt, dung and rubbish and sprawling on the road, immediately picking themselves up and scuttling up the heaps of rubbish again.

Five young men caught Mr Horne's attention. They were leaning over the rails of a pig-sty, traditional in the Black Country. It appeared that a silent communion was taking place between the pigs and the men, whom Mr Horne described as "very decently dressed". Soon a clock struck and a few seconds later the chapel doors opened to let out the Sunday school children. Some of them trotted primly down the steps, little black books under their arms, their clothes as neat as possible, if not always new. Others rolled out of chapel as wildly as the children playing on the rubbish heaps. Mr Horne noticed adults coming from morning service, most of whom were skilled workers, clerks and traders. But on the whole his chief impression of a Wolverhampton Sunday was "dullness and vacuity ... indifference and waste".

Not all Black Country people, however, spent their leisure either in contemplating captive wild beasts or communing with pigs on a Sunday morning. At Saltwetlls, near Netherton, there was a great attraction in the form of a saline spring, reported by Dr Plot as long ago as the seventeenth century. The proprietor, Mr Holloway, now advertised its splendours and gave it as the opinion of an eminent London chemist that it was one of the best mineral waters in the kingdom. It was said to have cured a pottery traveller from Brettell Lane of his disease of the skin, though before he was treated his hands, body, feet and head looked as though he had leprosy. Mr Holloway had hot and cold baths always at the ready, and rooms "neatly fitted up for the accommodation of invalids". Nevertheless, proposals to turn Netherton into a spa by piping the water to the centre of the village died a slow, lingering death.

There is little wonder that the working man's amusements were very often violent or apathetic and that people craved refreshment at the saline waters. Working conditions were dismal, sometimes even cruel. And though there was less ill-treatment of working children in the Midlands than in some parts of the country, cases are on record of barbaric punishment. It was alleged, for example, that nail boys whose nails were not true might have a nail hammered through their ears and be fixed down to the counter; or else they could be "wound up". If this happened, the master took the boy and put a hook into his trousers, fixing him to a winch which wound him through the trapdoor upside down on to the floor above. Mr Horne and his fellow commissioners on the Employment of Children report found that conditions varied greatly over distances of a few miles. It was alleged that Willenhall boys could expect worse punishment than anywhere, while in Darlaston children were not often beaten, and in Wednesbury treatment was particularly good.

In the Black Country pits all the coal face work was generally done by men, but large numbers of young girls and women were employed as

"bankswomen" to deal with the coal when it reached the surface. There were perhaps two at each pit head, and their task was to wait for the skep bringing coal from below ground, unhook it, tip out the coal, and replace the skep. Whatever the weather the girls continued their work, only breaking off in the severest thunderstorms or blizzards. Like their fellow women on the coal carts they seemed happy and full of song.

Other girls loaded coal boats on the canals, rode horses (sometimes two or three to a horse) and worked near ironstone pits picking out boulders and rough-sorting them. Observers agree that most of the girls were always smiling and cheerful, had enough to eat and enough clothes to wear, did not have to work beyond their strength and generally enjoyed what they did. They would swear, fight, smoke, whistle and sing and "care for nobody", as an investigator put it during the early 1840s. "They often enter the beer shops, call for their pints, and smoke their pipes like men."

Despite the general lack of bitterness, there was at least one great grievance at which working people up and down the Black Country fretted. This was the "Tommy Shop", where tokens given in the mine as payment had to be exchanged for food. This system persisted in spite of such parliamentary measures as the 1830 Truck Act. Whatever the weather the Tommy Shop had a queue outside waiting in rain, hail or snow. And orderly queues were things of the future; in those days a milling crowd with only the faintest idea of priority lounged or fought round the shop door. In the forays, clothes were torn, bonnets lost, feet stamped on. It was worse than today when the sales start in Wolverhampton, and in those days if you did not take part in the stampede you went without food. In the crush it was not surprising if women fainted, and any children waiting might find themselves trampled on and smothered.

Nevertheless, all these people had something to live on. But what about the very poor, the idle, the folk of low mental capacity, women whose husbands had left them or who had so many children they "didn't know what to do?" For such people it was either out-relief (when the parish paid a certain amount to keep them alive) or the workhouse. On 3rd January 1820, Rowley Regis vestry decided they must get some work out of the paupers in the poorhouse:

> It appearing that some work is proper for such paupers as may be in the poorhouse, Resolved that Sarah Challenger be set to break stones at the poorhouse under the inspection of J. Evans [he was the Beadle, later dismissed with ignominy from his post] and that she be kept to that work every day and always do a reasonable quantity before every meal is given to her and that the same course be taken with all other paupers in the house who are capable of work and that the stones to be broken

by women be first broken into pieces or brought to the place in pieces not exceeding ten or fifteen pounds and be broken with a hammer not exceeding two pounds into pieces not exceeding two or three ounces.

The Rowley poorhouse was situated at Tippity Green where nowadays the Christadelphian church stands. It was a stone building, limewashed white, and contained separate accommodation for men and women. In addition to stone breaking both sexes worked in the adjoining nailshop, which was closed in 1829 to provide space for a small sick-bay. In the sick-bay the floor was to be laid with bricks and the window looking out on to the garden stopped up, being replaced by another looking on to what is now the Dudley Road. This was to be "above the height of persons" who might look in and see the paupers in the sick-bay.

Of course, the parish officers did what they could to keep the poor alive. They were continually hampered by reluctance on the part of ratepayers to pay their poor rates, and chronic poverty resulted. Very often, however, the poor overseer spent the little money available in purchasing tools – now a nail-block, now a hammer or other woodworking tools – for the destitute man to pursue his trade. At times the parish officers would certainly dip into their own pockets, and once George Barrs of Rowley sent some port wine to a sick pauper at Windmill End. All the same, life "on the parish" was exceptionally hard. Pet dogs had to be destroyed, as they were taking food the parish could not spare; and little mercy was given to those hearty rebels who would not toe the line in exchange for their pittance of money. Sometimes angry women would bandy words with the officials if they did not think they were getting enough money, and they were firmly dealt with. All this was not surprising in view of the great debts owing to the parish from the ratepayers.

The Rowley vestry, bearded and whiskered, met in solemn conclave and decided to recover the rates from the greedy mine-owners by taking them to court. In 1807 an Act had gone through Parliament (one of many similar ones up and down the land) "for the more speedy and easy recovery of debts within the parishes of Halesowen, Rowley Regis, Harborne, West Bromwich, Tipton and the Manor of Bradley". Oldbury was chosen as the centre of this district, and a court set up. Down from Dudley came the Rev Luke Booker, otherwise known for his soul-searching sermons and pretensions to poetry, to give the opening address. The court house was built, together with a dreary debtors' prison.

If the Rowley vestry ever got their landowners and mining magnates into court – and there is no record that they did – they were met by an impressive sergeant with a gold band round his hat, and other officials fitly attired for the court. The fines levied would have been doled out very justly to the inhabitants of the parishes around who found themselves destitute. At the end

of the first year, £1 4s 2d went to the poor of Halesowen, £1 4s 2d to the poor of Harborne, and a guinea to the poor of Oldbury. Prisoners awaiting the hearing were forbidden ale and strong drink after some insulting behaviour by a series of tough defendants. More refined ratepayers had their own ways of defying the courts, and the Rowley vestry never really won the battle.

Meanwhile, there was an intense desire on the part of many people to see Parliament itself reformed. Though this was only one of the major reforms needed to bring Britain up to date, 1832 is looked upon as a landmark year in history. Up to this time there was not much representation for the industrial towns of England. Locally, Walsall, Wolverhampton and Birmingham had never been represented, and Dudley had not had a Member of Parliament since the Middle Ages. Many small unions throughout the Black Country supported the campaign of Thomas Attwood's Birmingham Political Union. The moderate and patient approach of this son of Halesowen saved the area from the kind of rioting experienced at Nottingham and elsewhere.

In all the main centres of the Black Country reform unions sprang up. The Walsall Union was formed in 1830 and demanded a representative in the Commons for Walsall. A shocking demand indeed! "Never before was such treason felony spouted at Walsall," wrote an observer. In Wolverhampton it was hoped to elect two Members of Parliament, and the constituency was to include Willenhall, Wednesfield, Bilston and part of Sedgley as well as the town itself. Everyone was very distressed when the Lords threw out the second reform bill on 8th October 1831. When the third bill was introduced flames and rioting at Bristol and other places gave pause to the bill's opponents, and as a result of compromise the measure was passed, limited enough in the extension of voting, but at least giving the industrial towns some say in the country's government.

One of Attwood's sons stood for Walsall in the first election, but the Tory candidate, a local banker, won the day. A Whig and a Radical were elected at Wolverhampton, while the Liberal interest at Dudley was successfully represented by Sir John Campbell, elected by a clear majority over his Tory opponent Sir Horace St Paul, a landowner and iron-master at Netherton, Sedgley and other local places. Perhaps the most colourful of this new clutch of M.P.s was Richard Fryer, the Radical representative for Wolverhampton. He prided himself on being "a plain-speaking man"; he intended when he went up to Westminster to reform the Church, make the Bank of England the servant, not the master of the people, and curb the power of the "selfish oligarchy of the landlords who ruled the country with a rod of iron, and made the agricultural districts one vast truck-shop". Despite these proud and hearty words Mr Fryer sat in one Parliament only, thereafter retiring to his country seat at The Wergs, his coat of arms duly granted him in 1835.

44. 'Watching the furness': *The Old Curiosity Shop*

By the mid-nineteenth century the Black Country had earned its name, though no one knows who first christened it. Dickens, writing *The Old Curiosity Shop* in 1841, called it a black region "where not a blade of grass was seen to grow, where not a bud put forth its promise in the spring, where nothing green could live but on the surface of a stagnant pool". Dickens was, of course, a specialist in the macabre, and on his visits here he must have been pleased to store up visual memories which he could refashion into descriptions for his novels. But there was certainly some basis for these descriptions. Grass had turned black; hawthorn hedges had withered and been trampled down; coal dust was to be found on everything, and the streams ran dusky instead of clear. Over the whole district hung a pall of smoke which turned bright colours to dull. Life was often hard: the collier's hours were long, his life perilous, and he spent his earnings at the Tommy Shop. But throughout the area there ran a vein of independence among the people, best epitomized in those laughing devil-may-care bankswomen, who would call for their pints in the beer shops and stand equal with the men. And often the workmen themselves were proud owners of some small plot of land, or some animal, or a bit of casually picked-up learning or traditional wisdom. Of these possessions, and of themselves, no one but they were masters.

AT HOME IN THE MINE
OR FIRE

> Oh, the slaves abroad in the sugar canes
> Find plenty to help and pity their pains;
> But the slaves at home in the mine or fire
> Find plenty to pity, none to admire.

The scene is Bury Hill, Oldbury, and the year 1860. The Black Country has now reached its zenith as an industrial region. Minerals are being mined at a vast rate, goods of every conceivable kind manufactured within a radius of ten or fifteen miles, transport has become much easier with the railways and continually improving roads. A London traveller has come to stay with a Quaker friend in Birmingham, resolved to find out all he can about the West Midlands and to publish whatever he finds. Here is his report on the view at night:

> The scene is marvellous, and to one who beholds it for the first time by night, terrific. Then the roaring furnaces are seen for miles around pouring forth their fierce throbbing flames like volcanoes; then the hundred chimneys of iron works display their blazing crests, or sheafs of fiery tongues; then the dull gleam of heaps of roasting ironstone makes you fancy that the old globe itself is here smouldering away; overhead dense clouds of smoke reflect a lurid light, rolling fitfully before the wind; while the hissing and rushing of steam, the clang and clatter of machinery, the roaring blasts; and the shock of the ponderous hammer strokes, all intensified by the presence of night, complete an effect which amazes at once the eye and the ear.

This is Walter White, whose book *All round the Wrekin* brings to life very vividly the Black Country in 1860.

Walter White pities perhaps; but he also certainly admires, marvelling at the omnipotence of coal and iron. On his train journey he sees stations, bridges, boundary walls, all built of bricks which have "a look of iron" about

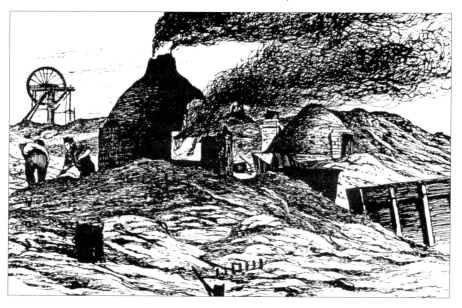

45. 'The glede oven'

them. As the train moves swiftly through bridges, along embankments, across roads and tracks, one can glimpse muddy canals, series of docks, mineral tramways with small trains carrying ironstone or coal on them, whimseys creaking at the head of mines, ruined coal offices and abandoned workings. Already there are great heaps of spoil as the pit banks encroach over the grass and hedgerows; and rusty equipment deserted when small mines went bankrupt litters the terrain. Here and there a small plot of cereal or potatoes braves the gloom, but all looks as though smitten by desolation.

Mr White walked the soles off his shoes discovering the Black Country, not content with a vague impression from the railway carriage. Let us follow him and his friend one warm day as they strike out from Oldbury bound for the top of the Rowley hills. Gradually they emerge from the smoke belt surrounding Oldbury (a place of smother on smother, says Mr White) and walk up Newbury Lane towards Portway. Passing Portway Hall and James Woodhouse's half-timbered birthplace, they are impressed by the village church, as conspicuous as that of Harrow, which with the exception of the tower has been rebuilt for nearly twenty years. Mr White notices the quarries, hard at work on the production of Rowley ragstone, with which the streets of Birmingham are paved, and then finds his ears much surprised by the click-click, thump-thump of hammers in nearly every house. All Rowley Village re-echoes with the sound, each cottage having its little forge in the place of a wash-house.

He and his friend look into every house, and the same scene greets them each time – women, three or four together, hard at work, with the assistance of a boy or girl in some cases.

> The fire is in common; and one after another giving a pull at the bellows, each woman heats the end of two slender iron rods, withdraws the first, and by a few hammer strokes fashions and cuts off the nail, thrusts the end into the fire and takes out the second rod and gets a nail from that in the same way. So the work goes merrily on.

Their reception from the nail-makers is a friendly one, and they find no difficulty in getting the women to talk. In another cottage, countersunk tips are being made, and one woman tells the visitor she used to be able to start work on Tuesday and make thirteen shillings a week; but now the hand-made trade is dying as machines can work faster. The morning walk proceeds along Hawes Lane taking in what is surely one of the most breathtaking views in the Black Country, the startling drop into the valley at Old Hill, by this time a vast hive of work in mining, brick-making, chain-making and the manufacture of such precision articles as gunbarrels. As the smoke rolls aside for a moment Mr White can see straggling houses as far as The Lye, and over the top of the cloud the bright green hills of Clent.

The pair then retrace their steps across Turner's Hill, with its ancient stone walls, and soon descend on the north side of the ridge, dropping down gently past the newly opened canal through the Netherton tunnel, the last canal tunnel ever built in England. At Tipton a sudden furious thunder storm overtakes them. They are then seen, fine gentlemen both, hoofing along remarkably fast in the direction of a lone miner's cottage. The door is ajar, and these soaking travellers rush in, delighted with the sight of a high heaped fire ("up to the gale-posts" as it would probably be described) and with the woman of the house's kindly welcome.

The afternoon is sultry, and the storm has not yet cleared the air, so our friends should be steaming nicely in the small room with their company of the woman, her daughter-in-law, husband, son and grandchild. The men are asleep on the floor, but they rouse themselves, not apparently very surprised at the sudden access of company. Mr White notices the cracks in the walls, leaning doorway and sinking windowsill, and comments that the landlord ought to do something about it. "He wo' do nuthin'," the man replies. "He says it ai' no use till it's done a-sinkin' and that wo' be never."

This landlord was very typical, and indeed he had some reason for his attitude. The truth is that all the mining activity of the first part of the

46. Black Lake canal bridge

nineteenth century had been so feverish and so grasping that no one cared how much damage was done to buildings on the surface so long as the coal came out of the ground. No one thought of the future at all. Naturally buildings began to cave in, and if the owners lived in these houses they might try to get compensation from the owners of the mineral rights. But often it was rented property over the mines, and the owners did not care. Or else the mine-owners and house-owners were the same, so nothing could be done.

Mining for coal was precarious not only for the miners beneath, but financially for the owners too. Often they were men without a great deal of capital, relying on scanty geological knowledge and middling luck to provide them with a living. They would buy mineral rights to a site in a way similar to the Klondike miners, hoping that their little stake would provide a rich return. When it did not do so, these small sinkers would abandon the trade and turn to something I else. And if they did succeed for a time, they simply had no cash to install the necessary drainage mechanism, and found themselves racing against time to remove the coal before floodwaters overtook their enterprise and the colliers hired by the butties. Even those colliery owners who had enough capital to carry out draining failed to combine with one another, and things had reached such a pitch by 1870 that 150 million tons of coal were said to be beyond the reach of man in flooded mines.

47. Black Country Industries, 1860

Because of this flooding an Act of Parliament was passed in 1873 creating a Drainage Board which could levy a rate and spend the money on clearing the mines of water. For various reasons this was not successful, and the northern section of the coalfield never recovered from this decline. Industrial depression, not only in mining, settled on the district. In Bilston and Tipton the numbers of men employed in coal dropped rapidly during the last half of the nineteenth century, and in Wednesbury mining had ceased entirely by the time of the 1914-18 war. At the same time the eastern edge of the coalfield was still expanding, and pits at Hamstead and Sandwell Park were sunk in the seventies.

At the midpoint of the nineteenth century the whole country was staggered by the glory and grandeur of the "Great Exhibition" in London, which on 1st May 1851 was opened by Queen Victoria. *The Times* reported the following morning:

In a building that could easily have accommodated twice as many, twenty-five thousand persons, so it is computed, were arranged in order round the throne of our Sovereign. Around them, amidst them and over their heads was displayed all that it useful in nature or in art. Above them rose a glittering arch far more lofty and spacious than the vaults of even our noblest cathedrals. On either side the vista seemed almost boundless.

All the nobility and quality of the country were assembled in what amounted to an enormous greenhouse. Many of the exhibits they looked at were made in Birmingham and the Black Country, and the enormous sheets of crystal glass of the building itself had been made at Spon Lane, on the borders of Smethwick and Oldbury, where Messrs Chance had possessed glassworks for twenty years.

The Chance family were of Worcestershire origin, and joined in partnership with a Bristol glassmaker about 1790. In 1824 Robert Lucas Chance bought the Spon Lane works from the British Crown Glass Company and within eight years revolutionized glass making in England. With great difficulty he secured the services of some French and Belgian workers who were familiar with the making of sheet glass, and thus broke the foreign monopoly. The whole Chance family were highly intelligent, keenly interested in the progress of the factory, and not only were they in very close control of the management but they were their own research team, developing techniques of grinding and polishing plate glass, the elements of which they had learned on the Continent.

James Timmins Chance, who joined the firm after coming down from Cambridge in 1838, was particularly concerned to perfect reflectors on lighthouses, and in 1859 was invited to give help to a Royal Commission set up for this purpose. He himself designed the prisms and lenses which were needed for the great lighthouses of the nineteenth century, and recruited a highly skilled team of workmen to carry out his orders. The overwhelming majority of glass for the lighthouses in Britain and the British owned parts of the world during those years was made at Smethwick; and all kinds of riding lights, steering lights and signal lights travelled the seas of the world to make Chance glassworks known everywhere. Like many of the nineteenth-century industrialists the Chance family were very generous to the local community, seeing it as part of their duty to pay back a good part of their wealth in terms of public parks, grants to churches, endowments for Birmingham University and so forth.

When Mr White, our Victorian traveller, visited the plate glass works he found the casting "an interesting operation at all times, but most so when seen in the sober twilight of an October evening. Then the pouring out of

the liquid fire, and the intense gleams from the furnace, appear awful in
the gathering gloom." But of all the works he visited, the most impressive
seemed to him Lloyds, Fosters' Old Park Works at Wednesbury. This might
well be so, since this firm was the biggest in Wednesbury and one of the
largest in the Black Country. Over three thousand men were employed
there in 1866, but no women. Through no fault of their own the firm later
lost a quarter of a million pounds in the erection of Blackfriars Bridge in
London, and the whole business had to be sold.

Mr White was amazed at the readiness to hand of raw materials for
steel making; for here at Wednesbury, on one side of the road he saw the
working coal-pit, while on the other was an ironstone and a limestone pit,
equally busy. He watched iron ore embedded in lumps of various sizes
and qualities raised from a pit 300 feet deep. The lumps were first rough-
sorted and then piled up ready to be roasted. Limestone was brought up
from 450 feet below ground, two hundred tons a day being used.

When the visitor and his friend were escorted across to the three blazing
furnaces, he found himself on an iron platform forty feet off the ground,
looking down on the foundry in the just-bearable heat. The fillers wheeled
their barrows across and emptied them into the furnace:

> The opening of the door makes us start back from the intolerable heat
> and glare, for there we look directly into the furnace, on a level with the
> summit of a huge mass of fire forty feet in height. We can almost fancy
> it a volcano, so fierce is the heat, so angry the roar; and are impressed
> beyond previous conception by the tremendous· forces required to make
> Nature surrender her mineral treasures.

Twice during the twenty-four hours ten tons of iron ore were drawn off
from each furnace, the liquid iron having trickled down to the hearth, now
separated from the rock and most other dross. To keep the blast going an
engine of a hundred horse power was needed.

It was a lengthy and exciting day for Mr White and his party. At five
o'clock they were to see the tapping process, and an air of excited restraint
accompanied them as they meanwhile looked round the wheelshops
(Lloyds, Fosters produced railway castings) noting the accuracy and
liveliness of the workers. As the chill October afternoon drew to its close,
they returned to the blast furnaces and stood watching the prepared sand-
beds, waiting to see the white hot iron pour from the tapping hole down
the sloping channel into the pit.

A laconic workman banged at the clay which stopped the hole; there was
a twinkle in the gloom of the autumn day and out rushed the molten iron
shooting like a fiery cascade into the huge pot. The stream of fire rippled,

till the pot was full and the stream diverted into the sandy channels, the main one called the sow and the lesser cross channels the pigs. Fumes of sulphur leapt from the molten metal, while workmen threw sand over it to exclude air while the pig iron cooled. In a later process its texture became tough instead of brittle, and the iron turned fibrous instead of crystalline.

In the meantime Mr White followed the huge ladle of molten iron to the foundry, and after watching the moulding here summed up the scene:

> The dusk of an autumn evening is the most favourable time for a visit to the foundry. Then the riotous flare of the furnaces sends streams of light across the floor, but all around prevails a gloom as of a vast darksome cavern, where here and there Vulcan has made ready his instruments of toil; and the hollow moan and fierce rush of the never ceasing blast seem unearthly to the ear. Then as the stream of fire leaps from the furnace the dreadful glare falls on roof and pillar, touches crane after crane, fainter and fainter as it recedes into the gloom and diffuses a halo round the dark figures of the men, as with the confidence born of use and practice they go through their sweltering task. And when at last the blast rushes through the slagpit, driving forth a storm of red hot clinkers, it seems as if the exciting scene were terminated by a burst from a volcano.

Many of the workmen whom Mr White talked to were earnest and determined to improve their lot in life. They took a pride in hard work and good craftsmanship, but they often found that profiteers of various sorts made their way harder than it need otherwise have been. The actual system of hiring men (in this and other industries), by which much of the labour was hired by a "butty" or sub-contractor sometimes militated against a fair deal. After work hours and at the weekends the men looked to Friendly Societies and Adult Schools for a chance to move up the social scale.

This was the heyday of the Nonconformist churches in the Black Country and the 1860s and 1870s provided countless "Ebenezers", "Mount Zions", "Salems", and "Noah's Arks", with their characteristic red-brick pediments, classical windows, stone copings and rows of foundation stones announcing the patronage of minor figures of influence in the local towns. Biblical names were given to many children, and Ezekiels, Zachariahs, Noahs, Enochs and Elis were ten a penny. Doubtless there was snobbery associated with these small chapels, and certainly there was humbug and hypocrisy at times, but they were places where genuine refreshment entered the hearts of the workmen and their families, where they heard the sonorous tones of the Bible read in its seventeenth-century translation, and where a great deal of thought was given to a very tough and disciplined morality.

48. A new sundial for West Bromwich church

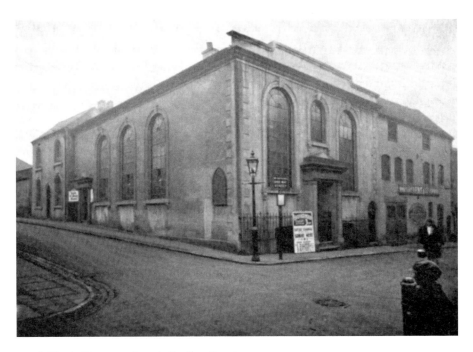

49. A Black Country chapel: Dudley Baptist

For example, Primitive Methodists ruled that no one could be admitted as a member who attended "vain and worldly amusements, wastes his time at Public Houses, buys or sells smuggled goods, vends or sells obscene books or pictures, fortune-telling books, or ballads". They expected their members to keep the Sabbath holy, which involved neither travelling nor working, buying nor selling, writing nor receiving letters, and trying to discourage public baking and the preparation of food on that day. Unmarried members of the congregation had to avoid marrying outsiders, and "plainness of dress should be practised both by private and official members". This communion, previously known as ranters, did not suffer from lack of recruits. The Puritan tradition looks to outsiders a joyless creed, but to these nineteenth-century workmen and their families life seemed like a battlefield on which the battle must be fought every minute.

As another sympathetic and intelligent spectator of this particular Black Country battlefield there came from war-torn America in 1865 an unusual employee of the American government. He was in many ways similar to the kind of workman we have just been talking about, self-educated, determined, appreciative and a thorough admirer of hard work. Elihu Burritt had once been apprenticed to a blacksmith, according to legend, and among the Midlanders with whom he worked he earned himself the nickname of "the learned blacksmith". As consul in Birmingham for four years he kept his eyes open, and before his term of office was up he had sent back to his government a report in the form of a book, published under the title of *Walks in the Black Country and its Green Borderland*.

Elihu Burritt was a man of peace, who knew that peace must be fought for. He ran newspapers, organized meetings, wrote letters to governments, and used all his energies in this determined crusade for peace in all spheres. But he also admired the Black Country struggle for prosperity, calling the view from Dudley Castle "the sublimest battle scene on earth". The contrasts between fire, smoke, cloud and the moon stirred in him the same awesome feeling that Walter White experienced; he saw the black, red and silver pageant and could only marvel at it.

> Wolverhampton on the extreme left stood by her black mortars which shot their red volleys into the night. Coseley and Bilston and Wednesbury replied bomb for bomb, and set the clouds on fire above with their lighted matches. Dudley, Oldbury, Albion and Smethwick on the right plied their heavy breechers at the iron-works on the other side; whilst West Bromwich and distant Walsall showed that their men were standing as bravely to their guns and that their guns were charged to the muzzle with the grape and canister of the mine. The canals, twisting and crossing through the field of battle, showed by patches in the light like bleeding

veins. There were no clouds except of smoke over the scene; but there were large strips of darkness floating with crimson fringes into the red sea, on which the white moon rode like an ermined angel of peace.

On Sundays the learned blacksmith, dressed immaculately and with prayer book under his arm, would walk gently from his house in Harborne to St Peter's Church, an object of interest and comment to the dozy villagers. During his four year stay they became much attached to him, and he to them, as well as to this southerly South Staffordshire parish and its rural views of Clent and Frankley. During the week he went on business or invited tours around the industrial towns. His descriptions are as graphic and observant as his pen picture of the scene from Dudley Castle Hill.

Near to Old Hill Station he was shown over the brick works where dark Staffordshire blues were made to the number of 100,000 a week. A great deal of the work was done by women of all ages; it was estimated at the time that three-quarters of those employed in brickworks were women. The consul watched keenly as a group of workers moulded the bricks at the moulding bench. A middle aged woman, whose only concession to femininity was the wearing of ear-rings, stood at the bench with butter sticks in her hands. A doughy lump of clay was placed before her, which she quickly turned into slabs with "a dash, splash and a blow". A small girl then took the "loaf" thus moulded to the drying floor, placing it with great precision in line with the previous ones.

The girl who brought the clay to the bench especially interested Mr Burritt. She was about thirteen, and "moved in a kind of swaying, gliding way as if muscle and joint did not act together naturally". She took a huge lump of cold, sodden clay, weighing perhaps twenty-five pounds, upon her head, then squatted down to grasp an equally large weight with both hands against her stomach; these masses of clay she took across to the moulding bench. She did this work for ten or twelve hours a day, and Burritt comments that it was not surprising that her cheeks bore an unhealthy flush. He was only surprised that children in such occupations grew at all: "she could only grow at night and on Sundays!" The pay for this was a shilling a day, which the woman moulder paid the girls out of her own wage; she hired her own "pages", just as the butties in coal- and iron-mines and in ironworks, hired their labourers or colliers.

Further north, Elihu Burritt visited Willenhall, where in company with local lockmakers he inspected conditions in the lock trade. This was notoriously hard work, deforming adults and children alike so that they had humped backs which became proverbial. Here as elsewhere, boys were apprenticed to workmen who had little capital, and had to drive their subordinates fiercely to make any profit. They were said to be particularly

vicious, punishing the apprentices by hitting them over the head with files. At Willenhall the consul also saw vast quantities of coal wasted, thrown out indiscriminately with the waste on to the pit banks, from which people in the vicinity harvested a rich gleaning. To Mr Burritt it seemed shocking when old people a few miles away were "clemmed" with cold and could get no coal because of the price.

At Bromford near Oldbury the learned blacksmith watched puddlers at work and stood amazed at their tremendous physique and skill. He watched the bubbling mass of metal "fished" out by the men, stripped to the waist and with sweat pouring from them, and saw the liquid metal thrust beneath a vast hammer or into a squeezing machine, throwing out a spray of impurities such as cinders, melted stones, etc. The squeezer was a large horizontal wheel turning in a semicircular case, into which half-liquid material was pushed, to be pressed into a constantly narrowing space until a compact elongated roll emerged, ready for the trip-hammer or rolling machine.

Retiring from his consular position, Burritt returned to America and lived another ten years in New England, keeping in contact with the region he had so admired during the late 1860s. He did not desist from his work for peace, and his writing brought to America understanding of British industry. To Midlanders his work has proved an interesting mirror in which they have looked at themselves time and again, pleased to see that at any rate this New Englander could understand and appreciate the spirit of zest with which the Black Country works and plays.

During the 1850s and 60s the Local Boards of Health began to acquire new powers, and were on the way to becoming the town councils which operated at the turn of the century, with all their pride, petty regulations, small-scale pomp, redbrick monuments and bitter wrangling. By 1855 Dudley Local Board had sub-committees for Finance, Health, Improvements, Lighting & Cleansing, Public Works and General Purposes, and employed five chief officers. Expenditure was still small, however, and only when Dudley became a borough in 1865 did the beginnings of any large scale financial operation occur.

When Wednesbury Local Board was inaugurated in 1852, its members were composed of clergy and prominent industrialists. The Board determined to keep down rates (a tradition which has not died) and like Dudley employed five chief officers and a number of part-timers. In West Bromwich the Improvement Commissioners took over from the parish vestry in 1854, dealing successfully with such problems as the outbreak of cattle plague in 1865, and the building of a town hall ten years later. This was designed by a Stockton-on-Tees firm and built by Trow and Sons of Wednesbury. Oldbury Local Board was constituted in 1857, the first

meeting being held on 22nd April. These boards, and their fellows in other towns, took the Black Country communities one stage further from their medieval village origins towards the large municipalities of today.

But still, no matter how efficient Local Boards became in the combating of disease in the nineteenth century, there was no end of work to be done. In Walsall there stepped on to the scene at this time a selfless woman, ready to play a vital role in alleviating the suffering of ordinary people. Later, she was called a saint by an Anglican Bishop, and he remarked of her that "England forgets her saints instead of canonizing them". Walsall has not forgotten Sister Dora – Dorothy Windlow Pattison – even today. Her statue was erected in the centre of the town in 1886, and roads and institutions have been named after her. Coming from Yorkshire in 1865, she took charge of Walsall's first hospital. The mob thought she was a Catholic, and answered her devotion with a hail of bricks against the hospital windows; but three years later when the smallpox epidemic struck the town she showed such bravery that they could no longer maintain their fury. She lavished care and love on ordinary people, whose relatives, faced with a frightening disease, had abandoned them. It is said that she went out alone to the small slum houses and fetched the victims in to be cured, or at least to be tended to the last.

Through colliery disasters and fever Sister Dora went on her persistent way determined to nurse people back to health where she could. One day there was a terrible explosion at a furnace belonging to the Walsall Iron Company at Birchills, an affair dreaded by all foundrymen. Seventeen men were driven nearly mad by the wounds they sustained, and some jumped straight into the waters of the dark canal to finish off their agony. But Sister Dora managed to reclaim two men and nurse them patiently back to full health again.

But soon, she herself fell ill, stricken with cancer. She refused to give up her work, and continued to explore ways of winning life for others. She fought her own disease for two years, and when she finally died she left a legacy of good behind her which is still recalled by public and private ceremonies every 16th January on her birthday. She was a herald of a new age in medicine.

THE END OF AN ERA

It was not only the tall stacks of factories and the smouldering refuse on pit banks that poured smoke into the atmosphere in the last part of the nineteenth century. In their own small way the railways of the Midlands contributed to the general sootiness of the air, the gloom of the day and the blanket of red-tinged smoke by night. The canals had reigned supreme for a very short while; they were slow because of the locks involved, and though much in demand for Sunday School outings, were not taken seriously by passengers; who quickly switched their allegiance to the iron road as this became available. For nearly half a century the railway boom was on. As a local ballad produced in 1837, and now popular again, remarked:

> You may travel by steam, or so the folks say,
> All the world over upon the railway.

For half a century, until the tide began to turn in the late 1870s, countless small companies were formed in the area, as they were all over England, to engineer some small line which would connect a minor town with its neighbour. But the giants in the battle for the Black Country were the London North Western and the Great Western. Even today the battle has only just been finished, as the lingering ghost of the GWR route from Birmingham to Wolverhampton has taken a great deal of extinguishing.

The first railway worthy of the name in South Staffordshire was a mineral line. In the middle of 1829 the Shut End line on the Earl of Dudley's estates began to operate from Shut End, Kingswinford, to Ashwood basin on the Staffs & Worcester canal. Seventy tons of coal could be carried on each journey, which took an hour for the three and an eighth miles. Soon, the emphasis moved to passenger lines, with the opening of the London to Birmingham railway (1838) and the "Grand Junction" which was completed in mid-1837, and passed through Perry Barr, Bescot, Darlaston, Willenhall, Heath Town and Bushbury. The Birmingham, Wolverhampton and Stour Valley Railway, which was to become the electric artery we

know today, and has always been popularly known as "the Stour Valley", was incorporated in 1846 and leased to the LNWR the year afterwards.

The other arterial line, called the Birmingham, Wolverhampton and Dudley Railway, was opened on 14th November 1854. The route was through Handsworth, West Bromwich, Wednesbury and Bilston; there was a link at Birmingham with the line to Oxford and London, and the track was seven-foot gauge, reflecting Brunel's belief in the broad gauge system. He felt sure that this gauge would enable trains to be speedier and safer, and hoped that the whole British railway system would eventually adopt "broad gauge". For various reasons his dream was not fulfilled, and in 1869 the Snow Hill to Wolverhampton line was converted to standard gauge.

By the late 1840s the LNWR was running four trains a day between Walsall and Birmingham, and a link with Shrewsbury was provided by the Shrewsbury & Birmingham line in 1849. In the west of the area, a poorly organized line officially designated the Oxford, Worcester and Wolverhampton, but generally known to passengers as "the Old Worse and Worse", was opened in 1850. Eight years later there occurred at Round Oak on this line an accident described by the Board of Trade inspector at the time as "the worst railway accident that has ever occurred in this country". Fourteen passengers died, and the story shows how much railway efficiency and safety have improved since then.

It all began with an advertisement which offered seats on an excursion train for a Sunday School outing. A very motley crew of supposed scholars booked on the train. Many were much too old for Sunday School; they smoked and drank, and apparently persuaded the guard to let them have a go at putting his brakes on. This jolly prank resulted in snapped couplings and temporary repairs, so that the train arrived at Worcester rather the worse for wear and not too tightly connected. It was intended to run the train back to Wolverhampton in two parts because of the sharp incline between Brettell Lane and Round Oak. This was done, but the two parts subsequently became three.

On this rather dark August evening, with rain threatening, the first part of the train arrived in Round Oak at 8.10. It was a heavy train and had been helped up the bank by a second engine added at Stourbridge. When it stopped at Round Oak there was a jolt and the guard (still with his roisterous companions) got out of the van. No one knows to this day why he got out, or what was going on; but in his absence the couplings he had so hastily repaired in the morning broke again. Inevitably, the rear part of the train detached itself, and began to roll back from the summit of the hill towards the oncoming second portion of the original excursion. The train could only have been saved by one thing: quick application by the guard

50. Darlaston Town Hall and GPO

of the brakes in his van. At the subsequent inquiry the guard said he had applied the necessary brakes. But the Board of Trade inspector found that the brakes had never been applied at all, and that in fact the guard could not have applied them, since he was still on the platform at Round Oak. The two rear coaches of the runaway train were smashed to pulp. A very heavy passenger load, which included irresponsible elements, insufficient maintenance, and careless employees had created a "Worse and Worse" situation.

Despite this sort of disaster the railways continued to expand. The Stourbridge Railway was opened in 1863, and in the subsequent decade Halesowen was linked with Bromsgrove, Old Hill and Dudley. But railway development was slackening, and it is significant that the proposed Wednesfield and Wyrley Bank Railway, incorporated in 1875, did not get beyond the drawing board stage. Saturation point had been reached. Most of the small railways had by this time been absorbed into the two giants, though the Midland Railway also operated in the area. The Great Western opened a locomotive works at Stafford Road, Wolverhampton, which for a time had some independence from the company's main works at Swindon, even using slightly different livery for locomotives.

The corresponding road link between Wolverhampton and Birmingham had originally been by horse-drawn coach. By 1851 horse buses were running six times a day on this route, travelling via Wednesbury. Hereafter the through service seems to have lapsed as the railways won the battle for traffic. The farthest town from Birmingham to have any road connection

soon became Darlaston, through services beginning from Darlaston to Handsworth in 1883, and being subsequently extended to Colmore Row. There was no through service again along the Birmingham-Wolverhampton corridor by road until the West Midland Passenger Transport Authority began the bus service through Darlaston in 1971.

After the passing of the Tramways Act of 1870, which clarified various aspects of tramway law, an era of trams began in the Black Country. At first these were horse-drawn or run by steam, but by the turn of the century electric traction became a cheap and clean alternative. Wires and gantries were avoided in Wolverhampton by the use of the "Lorian Surface Contact" system. The gauge used in most of the Black Country was only 3ft 6in instead of the standard 4ft 8½in gauge popular in northern towns. The narrowness of the gauge was one reason why Birmingham and the Black Country abandoned trams so much earlier than Sheffield, Leeds, Liverpool and Glasgow, since the narrower cars could not carry as many passengers and were less economical.

Steam trams as run by the South Staffs & Birmingham District Company were peculiar things. They were very much like two railway carriages one on top of the other. The steam engine itself was separate from the passenger carriage, and looked rather like a shunting engine with a vast funnel on the top. These extraordinary contraptions, clanking and puffing, and throwing out clouds of dirty smoke, were subject to severe speed restrictions by alarmed town councils. At Walsall, for example, eight miles per hour was the limit except near the Town Hall, where the driver had to drop to a reverent four miles an hour as he neared the august seat of government.

And certainly local government was by now becoming more dignified. A series of Local Government Acts during the second half of the nineteenth century had conferred borough status on the largest Black Country towns and amalgamated institutions such as Boards of Health, Parish Officers, etc., so that by 1898 the position became substantially the one which was to continue until well into the twentieth century. There were four county boroughs, consisting of Dudley (1865), Walsall (1835), West Bromwich (1882), and Wolverhampton (1889). West Bromwich had by now succeeded completely in the contest with Wednesbury for chief town in that area; Wednesbury was one of the non-county boroughs, its charter dating from 1886; the other being Smethwick, whose emancipation from Harborne had been advanced by the formation of Holy Trinity parish in 1841.

There followed in the hierarchy no less than nineteen Urban District Councils, ranging from well-developed and integrated towns such as Tipton and Stourbridge to centreless areas which had no very obvious

boundaries and were destined to be absorbed into larger units before long. Of these, Heath Town UDC occupied territory that had always been regarded as virtually a part of Wolverhampton. It was very much a working district, as it still is. Short Heath spread to the north of Willenhall and like its neighbour Wednesfield contained low lying desolate land and was dependent both on Walsall and Wolverhampton for most services. Lye and Wollescote, later added to Stourbridge, was a nail-making and colliery area, chiefly noted for houses made out of baked mud. Between here and Cradley Heath lay Quarry Bank UDC, later absorbed by Brierley Hill. The centre of Quarry Bank is the steep street leading away from the Stour Valley and the forge where Dud Dudley was washed out by flood tides.

On the extreme east of the Black Country was Perry Barr UDC, scene of the newly sunk Hamstead colliery. This was made up of a series of industrial villages without a shopping centre or any real community feeling, and it was not surprisingly divided between Birmingham and West Bromwich in 1928, Sutton Coldfield also taking a sliver. Next to Perry Barr was Handsworth, its ornate council offices on the main Soho Road designed by the same firm as West Bromwich Town Hall. Handsworth was much more integrated and commercially viable than Perry Barr, but its nearness to Birmingham, and the fact that parts of it were built over by Birmingham suburban housing, made it almost certain to be taken over. This was what finally happened in 1911, after a long wrangle.

At the end of the scale in 1898 came three rural districts, Halesowen, Kingswinford, and an area round Aldridge. Halesowen was still a pretty

51. A Victorian High Street: Brierley Hill

town with outlying villages at Hasbury and Cradley. Coal-mining coexisted with farming and the hilly country was not much changed from Shenstone's day. At its west end Kingswinford was also rural, with its village clustering near its old church and its several Georgian houses of distinction. Both Penn and Bushbury, later to be joined to Wolverhampton, were also under rural district authorities at this time.

All these authorities had plenty to do. In addition to matters of health and finance, rating and highways, they now had to deal with educational and cultural concerns. As towns grew, it was realized that people must have somewhere to breathe, and public benefactors began to see it as a duty to leave patches of ground in their wills which might have a few trees (laurel and rhododendron, plane and cypress) planted on them and be termed public parks. A rash of Victoria Parks sprouted in celebration of the Queen, and though often enough these are rain beaten commons, at least the space was saved in this way and more recently a great deal of variety and life has been introduced into their floral displays.

Under an Act of Parliament it became possible for towns to levy rates and run their own libraries. This was done increasingly in the Black Country from the 1870s. Some of these libraries, red-brick Gothic with stone copings, still exist. Often the most important feature of the library was a newsroom where local and national papers could be read free of charge each day, the racing page duly amputated and each paper firmly secured by a brass rod. The lending sections of these early libraries were not on the open access plan, and people had to ask at the counter for the books they wanted, a system which survived in West Bromwich until 1937.

Education for children took a big step forward at the passing of the 1870 Education Act. Before this, there had been an increasing number of schools built by various societies, mostly with a religious background. The old grammar schools, such as King Edward's at Stourbridge, Wolverhampton Grammar School, Queen Mary's at Walsall and Dudley Grammar School had taken on a new lease of life under the influence of the reforms in public schools initiated by men like Arnold of Rugby. They taught Greek, Latin, Mathematics and moral fervour, and their standards were high. Their pupils were mostly the sons of small manufacturers and professional men, the larger manufacturers having deserted local education for the public schools. Charity foundations like Oldswinford Hospital took on respectable orphans, but the ambitious workman's child attended the local National School or Church School before 1870, and enjoyed only a limited curriculum, possibly extending his education at an adult school in his own time and on his own initiative.

Under the 1870 act local school boards were formed in all the centres of population which were given power to take over existing schools and build

52. Bilston
Technical College

53. A terracotta
plaque from
Bilston

54. Bilston
Library

new ones, so that every child without exception should be able to read and write. A lot of the resulting board schools still exist, and seem lavishly built by our standards. They were not intended to collapse, and there are many clock towers, Gothic spires, bell turrets and great halls that have remained in good condition. They were often ornamented with mosaic, early English windows, pinnacles, stone leaf patterns and sculpture; and more importantly the original doors are still on their hinges, original tiles pave the passages and original girders continue to hold up roofs. Some of the buildings are dark, and the ceilings are much too lofty for today's taste; but at any rate no one could call these Victorian buildings shoddy. All this, in an average school building, cost about £4,000.

School boards took great care not to involve the ratepayers in any more expense than was necessary. It is said that at West Bromwich teachers were to do the job of attendance officers as well as their own, to save the board paying "kid catchers". So slow were the boards in moving that they became the object of scurrilous remarks and lampoons. A Bloxwich writer, using local dialect because, as he said: "Yone be able to understand it better," speculated on whether his audience would ever understand the Queen's English. Perhaps, he thought, when the school board gets to work – "though I'm afeerd that at the rate they'm a getting on moost on yu wun be grey-yedded afore that kums to pass". Despite these gloomy

55. A Freemason's hall foundation stone: West Bromwich

forebodings, education in the Black Country slowly became universal and by 1900 most of the younger generation could sign their names and took a pride in their copper-plate handwriting.

Popular taste in the late nineteenth century approved of medieval design. This was shown in the school architecture, the Gothic libraries and such curious monuments as "the Pepper Pot", a clock-tower memorial to Reuben Farley, first mayor of West Bromwich. More educated taste showed itself just as interested in the past, and the Wolverhampton manufacturer Theodore Mander built a marvellous mansion in a half-timber-style which was derived from the Elizabethans. The land had previously belonged to the Wightwick family, and the house was called after them, Wightwick Manor. At a first glance the house looks like a West Midlands timber frame house of the late sixteenth century: only some of the detail, and perhaps its good state of preservation, show its real age.

Furnishings and wall coverings for the house came from the firm of Morris and Company, headed by William Morris. In accordance with his burning convictions great care was taken to see that everything in the house should be made by good craftsmen. Wallpapers of great beauty, together with hangings which are still fresh and unfaded can be seen there to this day. The centre of the house is the "Great Parlour", which must have hugely pleased the rich industrialist with its vast oak fireplace, its lofty ceiling, tapestries and panelling. Painted glass in the windows of the entrance hall bears a strong likeness to Pre-Raphaelite work, and much of the house reflects Pre-Raphaelite feelings about art, even more so now than in the time of Theodore Mander, since the house now belongs to the National Trust who have brought other pieces of Pre-Raphaelite taste together in a superb collection.

It is perhaps interesting to note that Birmingham Museum and Art Gallery early became interested in the Pre-Raphaelites, and a number of collectors in the Midlands were drawn to their work. Such religious paintings as "The Light of the World" have still not lost their vogue among the older generation of Black Country people. Apart from the moral message the thing most admired about these paintings is the craftsmanship: a Black Countryman, who may sometimes fail to see the main point of a work of art, never ceases to wonder at anything done with real care and skill. Perhaps the long tradition of the japanning and enamelling trades has left its legacy here.

The pastimes and sports of the area were changing during the second half of the nineteenth century. Gone for years were the bull-baiting, bear-baiting and badger-baiting. Cock fighting had declined and become a furtive sport, taking refuge in hideouts among the pit banks. Prize-fighting had become civilized and the game of football was beginning. In West

Bromwich a group of young men who worked for Salters' scales formed a team to play on a patch of waste land near the works. Later they used a pitch in Dartmouth Park, named after the Earls of Dartmouth who owned Sandwell Hall. For some years they moved restlessly from ground to ground, justifying their first title of "West Bromwich Strollers" (though the name "Albion" was used as early as 1880). But in 1900 they were able to take over a pitch at the Hawthorns, right on the boundary with Handsworth and Smethwick. They have always been a lively first division team and won the F.A. Cup in 1888, 1892, 1931, 1954 and 1968.

The famous Wolves are the Albion's close rivals in the Black Country. They were among the twelve founder members of the Football League in 1888, and have won the cup three times, in 1893, 1908 and 1949. The struggle between Albion and Wolves is a perpetual one, great crowds being drawn to the local Derby games. But among the many clubs which started their lives in the 1870s and 1880s it cannot have been easy to judge which would be carrying on the football tradition a hundred years later, nor which would be first division teams and which, like Walsall F.C., would generally be found in a lower league. This latter team stemmed from the amalgamation of the "working class" Swifts and the more aristocratic "Town" club.

Meanwhile the hardships of the people were very slowly being alleviated. Coal-mining, however, still affected everyone, even where pits

56. The Wolves 1971-2 programme

had been worked out. Wild-fire continued to spread fast underground, certain towns being particularly well known for this hazard. At Rowley Regis the new church began to collapse, and roads in Cradley Heath cracked across as the land subsided over the now empty galleries. Tie-bars were used to stop houses falling to pieces, and people got used to drunken footpaths and cracking drains. Though the coal trade was on the decline there, Wednesbury was still the scene of wild-fires as it always had been. Mere cracks in the earth and subsidence were nothing to the crownings-in, which left huge gaps in the ground where flames shot into the air, and about which nothing could be done.

A typical example was the fire in Old Park Road, Wednesbury. This broke out in 1895 and was still growing a year afterwards. Despite efforts by the council, whose attack was spearheaded by the borough surveyor, there seemed to be no way of fighting the fire. By early 1897 a huge hole had appeared in the road and the sewer went up in flames. To make things worse, no one could agree on the liability the rate conscious town council refusing to pay towards the fire's control and the mine owners maintaining it was not their fault but a tenant's. One could not really blame the council. They had inherited the difficult position that if they had taken on the duty of clearing all rubbish caused by mining, or stopping all hazards to life resulting from mineral extraction, they would soon have been bankrupt. The truth is that throughout the century many industrialists had been getting their profits cheap at the expense of the public in general, whose amenities meant nothing to them. One night, however, at Wednesbury the night watchman fell into the fire and was suffocated, and at last real efforts were made to stop the coal burning. A band was cut through the seam and non-inflammable material was put in the way of the fire. The conflagration was halted, but not until it had been burning for over three years.

By now the Board of Trade was interesting itself in the conditions of the nail and chain makers in the south of the Black Country. In particular, concern was felt over conditions facing female labour in Lye and Cradley. The authors of the report saw women working on spike nails as large as eight inches, sweat streaming from their faces, and suffering from utter exhaustion by the end of their twelve hour day. This work earned them between 2s 6d and five shillings per week, and the reporters doubted whether this was enough to compensate for their loss of time at home.

Conditions in the houses themselves were also very difficult. There was, of course, no running water, nor indoor sanitation. Water had to be fetched from a pump in the "fold" or yard, and the toilets were earth closets at the end of the fold. It was said that the women had no notion of domesticity, and in any case had to go out to work for most of the week to keep husbands who were out of work. Their labour made them flat-chested and

thin, though their arm muscles were wiry and tough. Constant toil in the heat of a fusty workshop caused them to be pale-skinned, and they seemed uninterested in anything.

The younger women brought their children to work with them, or else paid child-minders to look after them. Some of these children would be seated by the hearth while their mothers worked, or else they might be slung on chairs suspended from the rafters, or laid to sleep on the blow-bellows by the fire. Some young women had illegitimate children, but the reporters could not say whether there was greater laxity in the chain and nail trades than in workers in any other industry. The nail trade was of course dying; this part of the area was almost its only home at the end of the nineteenth century, and here too the writing was on the wall.

Life had its pleasant aspects, particularly for the better-off folk. While the nailers pushed their small carts of nails through the streets to the foggers, the middle class children snuggled into their beds happy after a day's ramble to Clent or Hunnington. Or perhaps they had travelled by horse bus from the Stag at Quinton into Birmingham for sixpence, with the three horses straining at the bus up Hollybush Hill. Sweets cost very little, and a halfpenny would buy a small packet of them, or two small farthing buns. In Halesowen a whole ox was roasted each year at Great Cornbow, providing a marvellous day's excitement for all the children, not to say the hungry adults. Somehow, old people when they look back to their childhood never seem to remember the terrible cold of the winters. Their stories are of skating on long lost ponds, walking on iced-over canals, and eating roast potatoes and chestnuts in front of roaring fires.

At the end of the nineteenth century most of the families living in the Black Country had been settled for hundreds of years. In many towns and villages people lived within sight of their birthplace, and of the birthplaces of their parents and grandparents. Even today the West Midlands phone book contains much the same localized surnames as the Staffordshire Hearth Tax of the seventeenth century. The growth of nineteenth-century industry had caused some immigration, especially of people from Wales, Ireland and Shropshire. The Welsh strengthened the Methodist tradition, and the Shropshire miners soon integrated well. Many had come from derelict spar mines in the hill country beyond Shrewsbury to become colliers or sinkers in Black Country coal pits. The Irish formed their own communities at first, but they too gradually became part of the Black Country, with only a surname to tell of their origin. On the whole, as the twentieth century dawned, continuity remained important in Black Country life: trade, language, religion, independent spirit, were all passed down from father to son, with grandfather benignly in the background. This situation often still exists.

It is this closely hemmed-in community life, concentrating on small and trivial events, that makes the Black Countryman (not to say woman) such a gossip. Horizons are narrow, even now. By and large, they were even narrower at the beginning of the twentieth century. An old newspaper may catch for us the tone of Black Country life during the time in January 1901 when Queen Victoria lay dying. When the *Birmingham Weekly Post* reported the Queen's death, it contained in the same issue a fair crop of local incidents. The landlord of the Whimsey Inn at Dudley Woodside, for example, came to sudden grief through an accident with a horse. While his friend went into a public house Mr Dainty sat outside in the trap, and turned the horse round to face the other way. As he executed the manoeuvre the wheel of the trap caught a tree stump by the roadside, the trap overturned and threw Mr Dainty underneath, killing him.

A widow living in Horseley Fields at Wolverhampton was burnt to death, crying out that her grandson had set her on fire with a lighted paper spill. The coroner's court proved that the lad was in another house at the time. In another case, one Bertha Jones of Roseville, Coseley, fell on the fire in a fit, but her burns were not so severe as to cause death. A collier died at Himley after a lump of coal shot from the coal face where he was working and struck him with tremendous force; at Rushall a Kingswinford miner was charged with causing cruelty to a pit pony by striking it with an iron bar and making a gash eight inches long in its nose; the incidents in coal mines make dismal and squalid reading. In the pit pony case the man was found guilty and had to pay a fine of £2 7s 6d. Meanwhile at Bilston police court a woman was sentenced to four months' hard labour for a repeated offence of cruelty to children. She was said to be addicted to drink and idle habits, leaving her four children every day in a filthy condition.

But perhaps the best local "scoop" of the week for a cub reporter occurred at Oldbury police court, where a prisoner in the dock obliged the assembled company with a short rendering of "Tom Bowling". If the court evidence is true, Police Constable Shelvock was pounding his beat along Birmingham Street one cold night and, as he passed the Church Square, he heard strains of music. A small crowd was watching a concertina player, who took off his cloth cap and passed it round. As the money chinked into the old man's hat the policeman intervened, arresting him for begging. When the sombre court assembled next day the presiding magistrate was Mr A. M. Chance, head of the alkali works and a philanthropist, himself now an old man with a fine career to his credit. The prisoner, Mr Mead, must have known that there was a fair possibility of getting off.

"I was singing for my living," he asserted forcefully when asked if he had anything to say to the charge of begging.

"What do you sing?" the magistrate asked.

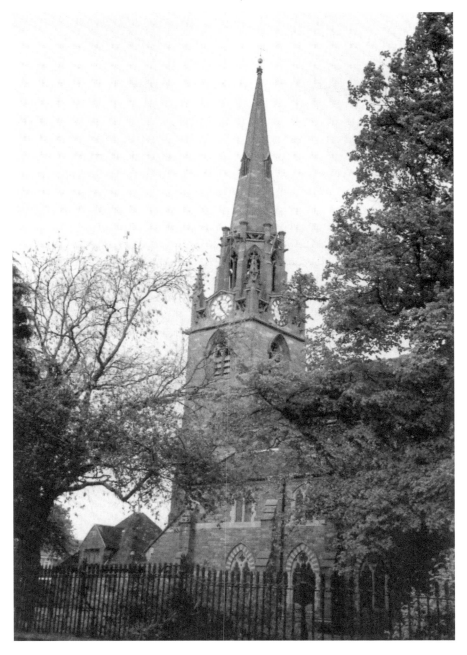

57. St Lawrence's, Darlaston: a Victorian rebuild

And that was how it came about that almost a whole verse of "Tom Bowling" was rendered by the accused, in a fine tenor voice. Roars of laughter accompanied the singing.

"Yes, thank you," said Mr Chance. "I am assured you have got an excellent voice. I shall dismiss the case; but in future I advise you to make your singing a matter of business, not begging."

On its main pages the *Birmingham Weekly Post* dwelt melodramatically on the Queen's death. Undoubtedly, the mourning was heart-felt, as people recalled her early visit to Birmingham to open Aston Park in 1858, or her visit to Wolverhampton in 1866 to unveil the statue of the Prince Consort. Among the marks of sympathy were the flying of half-masted flags at Handsworth public offices, the abandonment of Wolverhampton steeplechases, theatre programmes postponed at Walsall, the cancellation of a banquet at Wordsley Conservative and Liberal Association, telegrams of condolence from municipal authorities at Walsall and Dudley, and the postponement of the Bachelors' Ball at Stourbridge Town Hall.

It was the end of an era. An extraordinary reign had ended, full of achievement for British industry and its Midland heart. So many things had happened since the Queen's accession that Britain was transformed. Industry had become methodical, factories had replaced small workshops, poverty was receding; municipalities had succeeded parish vestries; education was spreading, so that universal literacy could be expected; the railways and later the tramways had made it possible to move about with ease; the humanity of men like Alexander Chance sorted out real criminals from the weak-willed with more justice than of old; sports were less bloodthirsty. In many ways it must have seemed as though the millennium was at hand.

THE BLACK AND THE GREEN

The twentieth century did not bring in the millennium, either for the Black Country or anywhere else. During the first fifty years it brought two devastating wars in which many men were lost. There were rapid changes, which left the older folk wondering whether the world was coming to an end. True, the century gradually brought cleaner air and better working conditions; but on the other hand there was slaughter on the roads, and churches and chapels declined. By mid-century, Black Country coal-mining had relapsed almost into non-existence. After the Second World War canals were filled in and railways closed: even bus services were beginning to thin as the West Midlands became one of the most car-conscious areas of England.

Yet still, between the wars, there was a strongly individual aura about the Black Country. Many pits in the newer areas of the coalfield were still at work; blast-furnaces ejected flame and sparks up towards the cloudy moon; the canals were busy with narrow boats constantly passing and returning. Everywhere there were narrow gauge mineral railway-lines bridging many streets and burrowing under others. Even the new highway from Birmingham to Wolverhampton, opened in 1927 to alleviate unemployment, did not avoid the mineral bridges. There was little new housing at this time and large tracts of open country still remained behind all the towns and villages. It was usually a desolate countryside, pock-marked with craters where coal or ironstone had been worked and littered with artificial hills-the pit banks which had gradually grown there over eighty or a hundred years. But children played happily amidst the desolation, with few people to stop them doing as they wished.

The older people retained the dress their parents had been used to. Women nailmakers wore black boots with laces, woollen stockings, a long skirt with a plaid shawl, a man's cap and a clay pipe. The men wore highly coloured shirts, huge leather belts with buckles, and thick boots; they, too, were often to be found smoking clay pipes. Some walked miles to work where a pit remained open or some enterprising manufacturer had turned

THE
BLACK DIAMOND

by

F. BRETT YOUNG

LONDON: 48 PALL MALL
W. COLLINS SONS & CO. LTD.
GLASGOW MELBOURNE AUCKLAND

58. Title page from
Brett Young's *The Black
Diamond*

from boatmaking to car accessories; or they got up early in the morning to face a tram and train ride to a factory in Aston or the chocolate works at Bournville.

In Halesowen there was born a man who put all this on paper in novel form. Francis Brett Young was the son of a local chemist and was born in 1884 at the Laurels, a pleasant house standing away from the road but very convenient for Halesowen town centre. His parents had ambitions for him and sent him away to school, but he returned to Birmingham Medical School to finish his education in the early years of the century. And in his books there are many descriptions of the Iron City and its Black Country relations, sometimes laced with bitter condemnation, sometimes with perverse loyalty. The "squalid slums" that horrified the young physician in the book of that title written in 1919 give place to the "grace as well as grandeur" of Colmore Row in *Dr Bradley Remembers* written in 1938.

59. A variety of housing: Rowley Village

Doctor Bradley, hero of this book, takes up a post at "Sedgbury" (like Thomas Hardy and Arnold Bennett, Brett Young invented names for local places and combined various scenes together), and is soon involved with the nailers and colliers. Brett Young lists the products made from steel which Sedgbury produced – anchor chains, tubes, buckets, spades, galvanized sheeting, saucepans and dog leads. Here Doctor Bradley wakes in the morning, not to the song of thrushes and blackbirds that had roused him in his country boyhood, but to "the melancholy hoot of the bull (the works siren) in Aaron Sanders' perambulator and-go-cart works, whose new buildings and tapered smoke-stack, together with the terracotta villa in which their owner chose to live and keep an eye on them, had sprung up with alarming speed on the site of the Crabb's Lane nailers' cottages".

In contrast with all this industry, squalid to look at, yet somehow mysterious and awe-inspiring, Brett Young Wrote about the ring of coloured countryside surrounding the Black Country, the Worcestershire and Shropshire hillsides yellow with gorse and mauve with heather. Between the wars several of his books were best-sellers, favourites in circulating libraries and sold in any bookshop up and down the country. In all his Midland novels the conflict recurs between the Black and the Green, the beauty of nature and the dark morbid growth which threatened it, expanding and creeping till the rivers died and the fields wilted. Somehow this struck a chord in the minds of the public, and they bought copies of these novels in thousands.

Despite this, Brett Young's fame died. A contemporary and friend of D. H. Lawrence, he disagreed radically with Lawrence's way of writing,

his dissection of the human being, his interest in the depths of human motive. Brett Young aimed to write pleasing stories about ordinary people, but his ordinary people turned out to be limited to the first half of the twentieth century, often cardboard dodos who lacked depth. All the same there are some lively portraits of Black Country scenes in the books, a rich vocabulary, and careful craftsmanship. There is poetic feeling and warmth, genuineness and honesty without false sentiment. Brett Young's work showed that from the Black Countryman's talent for making things, the making of literature was not entirely exiled.

Some very startling and spectacular events occurred in the area during the first half of this century, and there were some mysteries. For example, who set fire to and burned to the ground Rowley church in the middle of the summer of 1913? Rumour suggested suffragettes. Certainly there was a lot of activity locally on the part of these militant feminists, demanding a vote and a say for women in the affairs of state. And then two letters were received after the fire was over, one – rather illiterate – postmarked in Bilston, maintaining that:

> if we do not have votes for women before long it will be the church at Wolverhampton and then at Bilston, and then at Willenhall and then at West Bromwich and it will be by Mrs Pankhurst orders. If you do not send £506 to our headquarters in London in a week time from now your life will be in danger by Mrs Pankhurst orders. It was Mrs Pankhurst orders to we to burn the church right down.

60. Old cottages at Blackheath

Hardly likely to be genuine, that letter, and the vicar did not send the money nor believe that suffragettes had been the cause of the fire. Nor did he think local strikers had lit the blaze in the organ loft where the fire was proved to have started. He refused to blame them, and in fact said he supported their cause. Whoever started the fire, it was a truly spectacular event – the burning of a major building with so much timber inside it, set high on a hillside overlooking a valley and visible for ten or twelve miles.

It was on a summer's evening that the alarm was raised; a day on which a late baptismal service had been held. A passer-by looked up to see the time and was startled to see smoke drifting out of the west end of the building. As he watched, the smoke turned to flame – yet only twenty minutes before the verger had locked the door after the baptism was over. The passer-by wasted no time in speculation, but rushed to give the alarm which was received and quickly acted upon by the Blackheath division of the Old Hill fire brigade. They came tearing up the hill out of the valley, over which smoke was beginning to billow, bells clanging, and the rattling primitive motor straining up the steep lanes. Dusk was still some way off, yet the hillside seemed already dusky, as flames shot into the air and the churchyard vanished under a pall of smoke.

Less than half an hour after the outbreak the hoses were trained on the building, but almost immediately the water supply failed, only a weak trickle of water emerging from the efficient hoses of the enthusiastic firemen. By now the west end was a holocaust and the roof was being consumed; flames leapt up the tower and there was heard the crackling of pitch-pine as the interior woodwork blazed and vanished in ashes. In the gathering gloom of the evening, the fire swept through the rest of the building, gutting the belfry, nave and aisles, smashing the old font, melting stained glass windows and frizzling documents hundreds of years old. The firemen struggled with the old parish chest, determined to save it. They tied ropes round it to drag it free, but the ropes burned through. Finally they got it out of the devouring fire, its contents charred, pages lost here and there, but much of it still legible. What those firemen saved was Rowley's priceless heritage: this book you have read would have been poorer without it.

This extraordinary event was looked upon almost as a portent, especially since Rowley's first church had proved the death of its devoted curate George Barrs, who wore himself out in efforts to have it rebuilt; the second had shown signs of falling into a coal mine; and now the third had been wafted away on the air of a breezy June night. Worst of all five days later the church would have been properly insured, but at that moment it was not. At any rate the point of origin of the fire was known – the organ loft. Had someone, who had been practising the organ and smoking at the

61. Darlaston war memorial

same time, dropped a lighted cigarette and so created the inferno? This was a possibility the church officers dared not think of, and they smartly announced that Rowley people were above smoking at the organ.

The only suspect was a foreign looking person who had been seen near the quarries during the afternoon. He had asked about the church, and perhaps he set it alight. But it didn't seem very likely. The culprit was never found and the mystery still remains. Suffragettes, strikers, foreign spies, the organist were all suspected and exonerated. Crowds of people watched the fire burn late into the evening as the fire brigade retreated after brave efforts to save the church. Amongst the spectators was almost certainly the culprit, drawn to the scene of this most spectacular crime. Possibly there is still someone alive who holds the key to the awesome burning, but it is unlikely that we shall ever know the full story.

Within just over a year of the Rowley fire the nation was plunged into the First World War, and the soldiers marched to France singing a song written in West Bromwich by an Oldbury man. It is said that on New Year's Day 1912 Jack Judge, singer and composer, went to a pub in West Bromwich and a bet was made that he could not write a song and the music and sing it on stage all on the same day. He sat down at once and wrote It's a long way to Tipperary, composed the music and took the whole thing up to Lancashire where that night he sang it at Stalybridge Grand Theatre. The song was adopted by the Tommies in the war and became a classic that is unlikely to perish.

A vast toll of young men's lives was taken by that war. A small area like Bloxwich, with Leamore and Blakenhall, lost 306 men, and all over the Black Country memorials were set up to the dead. Some were in the form of churchyard crosses, distant descendants in form of the Saxon cross at Wolverhampton and the medieval cross in Bloxwich churchyard. Memorial tablets were erected in banks and post offices, municipal offices and works, and gardens were laid out in remembrance. Public parks, such as Dartmouth Park, West Bromwich, were frequent sites for memorials.

Those who remained at home during the war, as we are reminded in many of Brett Young's novels, began to prosper on the munitions trade, which gave considerable impetus to the diversification in industry which had started late in the nineteenth century. All the same, throughout the area the chief industries were still mostly concerned with metal, the main exceptions being leather goods at Walsall, glass crystal at Amblecote, Brierley Hill and Stourbridge, brickyards here and there, confectionery and plate glass at Smethwick and rayon at Wolverhampton. The 1931 census showed that forty per cent of Black Country workers were involved in metal trades.

The population went on rising between the wars, but not evenly. Darlaston, West Bromwich and Smethwick, which were close-packed against their neighbours, couldn't accommodate all their citizens and services, and exported both people and institutions, taking up land in other towns nearby for housing, hospitals, and schools. Other places in the middle of the Black Country – Tipton, Wednesbury, Bilston and Dudley – lost slightly to surrounding areas. Development took place at Tettenhall, Wednesfield, Sedgley, Oldbury and Halesowen during the 1930s when both private and muncipal housing was built rapidly.

One of the obvious features of the modern Black Country is the municipal housing estate, begun during the late 1920s and 1930s – sprawling two-storey estates with their narrow roadways and sparse grass verges at Hateley Heath, Friar Park, Bloxwich, Low Hill, Kingstanding, Warley Woods and many other places. Since then municipal estates have become more diverse; they are much better landscaped and contain a mixture of housing types – maisonettes, low and high rise flats as well as conventional housing. Schools, churches, shops and other services are laid on. Derelict land has been reclaimed for housing, and play areas are being made for children by the levelling of pit banks and filling in marl holes.

By the Second World War the oil-driven bus had become the chief means of transport in the Black Country. Three county boroughs, as well as Birmingham, ran bus services in the area, and two of these, Wolverhampton and Walsall, also used the "noiseless" trolleybuses which swished along like ghosts or buzzed like wasps. The West Bromwich undertaking built up

62. Twentieth century alongside nineteenth century: Hill Top

63. Twentieth-century roadhouse

a fine financial record, fares being low, yet small profits being made every year. When the last trams in the Black Country ran on the Birmingham to Dudley routes just before the war, they were mourned only by a small band of enthusiasts, not by the general public who considered the rails and wires unsightly and the difficulty of passing vehicles which kept to the middle of the road a considerable nuisance.

Wolverhampton, however, had disliked the idea of tram wires from the first, and thus had chosen the surface contact system previously mentioned. After the First World War the equipment was too worn to be economically maintained, and the council sent representatives to view the Nechells trolleybus route in Birmingham. As a result of this visit it was decided to convert gradually to trolleybuses throughout Wolverhampton and on the services to Sedgley, Dudley, Wednesfield and Darlaston. During the 1930s Wolverhampton had the biggest trolleybus system in the country. The Second World War brought difficulties in maintaining the fleet, and Wolverhampton citizens were startled one day at the appearance of a number of bright yellow trolleybuses among the green fleet. They had been borrowed from Bournemouth Corporation for the duration of the war.

Walsall followed Wolverhampton in buying trolleybuses, but never had so many. On the Leamore and Bloxwich routes trams survived until 1933, after which trolleybuses built by Sunbeam took over. By the outbreak of

war there were twenty-one trolleybuses and 157 motor buses operating in Walsall's light blue with yellow lining, covering districts as far apart as Cannock, Willenhall and Pelsall as well as the nearer environs of the town. After the war Walsall transport invaded Aldridge, Kingstanding, Great Barr and Birmingham, and light blue buses became as common as red along the main Walsall to Birmingham trunk road.

Elsewhere in the Black Country the red and yellow "Midland Red", based at Bearwood, gradually took over all the tram routes, and had almost a monopoly in the south-west from Dudley to Stourbridge, where garages were opened at Cradley Heath, Harts Hill, Dudley, Oldbury and Stourbridge itself. Most Midland Red buses were built and maintained entirely at Bearwood, the company being one of the few in the country to find it cheaper to carry out all the processes itself instead of contracting out. Midland Red buses before the war were highly individual vehicles, even the double deckers having front entrances with closing doors, and the whole fleet using home-made engines. Everything, right down to such accessories as destination indicators, was made by the company at its works.

Civic pride in the main Black Country towns grew between the wars, but nowhere was this more the case than at Dudley. The red brick Town Hall was opened in 1928, winning an architectural prize for its airy design (though nowadays it might remind us of a cinema), and was followed a few years later by the Brooke Robinson Museum and Council House. But the most exciting event in Dudley was the opening of the zoo in the castle grounds, which were expertly landscaped and in which use was made of rock caverns for lions and bears, and the castle ruins were integrated into the scheme with care. The castle hill then became even more a playground for the region, nearer at hand than Kinver or Clent and with more for the children to do.

Almost on the eve of the Second World War Wolverhampton borough proudly opened the Civic Hall, despite opposition from some ratepayers who thought it might be a white elephant. In fact, the hall has made it possible to invite excellent orchestras regularly to Wolverhampton and it has become an indispensable part of the life of the town, further enhancing the musical and choral tradition for which Wolverhampton Festival Choral Society had long been famous. The hall has made a worthy cultural neighbour for the Art Gallery, opened in 1884, and has helped to form the musical taste of many young people from Wolverhampton and further afield.

All the cultural and civic advances ceased when in September 1939 war was declared with Germany. Soon, prominent buildings were being painted to look like fields, blackout precautions were in force and road blocks

were being prepared to hinder German tanks if they got this far. Barrage balloons sailed high in the sky like flying elephants and smoke-screen equipment was set up so that the whole area could be enveloped in a more than usually dense cloud of smoke. Factory sirens – the works' bulls – were converted to emit the wailing warning of enemy approach, and were used many times in 1940 and subsequent years. The Dorniers and Heinkels were after a rich industrial harvest, seeking out the tube manufacturers and the plane makers. More often they missed their true targets and smashed West Bromwich gas showroom or set fire to Birchills bus garage. By 1945 Hitler had considerably furthered the work of changing the old Black Country and making necessary a vast reconstruction effort.

But the Black Country does not abandon its history. Old buildings have to go; industrial methods, even the industries themselves, pass away and are replaced. Yet in the speech, customs and habits of the people there is a continual reminder of the past. Traditional sayings die hard, old songs are revived, the place names themselves preserve history like a museum brought to life. Stories and yarns go on being retold with the 'Black Country Night Out' a popular entertainment. Religious ceremonies linger, and the children retain their store of rhymes and games with aged pedigrees. Sports may be less brutal, but they are still taken very seriously.

The memory of old-time sports is carefully cherished. Wednesbury, the home of cockfighting, with that odd lectern standing in the parish church, possesses a wild and vital ballad called the Wedgbury Cocking. Tunes to it are rare but everyone knows some of the words. It was probably composed in the eighteenth century and tells of a violent meeting between cocks belonging to Newton and Scroggins. In one of the highlights of the match, which developed into a free-for-all:

> Peter Hadley peeped through the gorse
> In order to see them fight;
> Spittle jobbed his eye out with a fork.
> And cried "Blast thee, it served thee right!"

Other ballads tell of dog-fights and bear-baiting. now abandoned for the tense but more humane pastimes of pigeon-flying and whippet-racing.

Not many people still cry their wares in the streets, though here and there you can see the rag-and-bone man, now in a small pickup, raising to high heaven the cry of "Rags! Bo-o-ones! Old Iron!" and the raucous voices of the news-vendors still echo across Queen Square to advertise the last edition of the *Express and Star*. Between the wars the watercress sellers used to set out from Darby End near Netherton with their cries, carrying their "fresh watercress" through Dudley and district. From Gornal

came energetic sellers of "lily-white sond" whose tongues were racy and wits sharp. Once a mayor of Wolverhampton asked what happened to their donkeys when they died. "We sends 'em to Ampton and meks town councillors on 'em," was the sharp rejoinder.

Old miners, now retired, have hardly yet finished telling stories of their collier days and how superstitious their colleagues were. Just like sailors, they relied on portents to guide them in their dangerous task. You must not go to work, for example, if on your way you meet a cross-eyed woman or see a robin on a wall, nor after a dream of fire or a broken shoe. One of the best remembered ballads in the area is the sad story of a collier's daughter who has a frightening dream and pleads, "Daddy, don't go down the mine." To a generation born into a world without pits – the last at Baggeridge was closed in 1969 – this song seems antiquated, but to the music hall audiences who heard it a hundred years ago it was imbued with awe; whenever a collier left home in the morning he wondered whether he would see his home again that night. Some of these superstitions are very old: meeting a woman on the way to work brought bad luck to colliers as long ago as 1711.

The dialect of the Black Country sounds most peculiar to any stranger, yet it is likely that Shakespeare would understand it (the name Shakespeare is still common in the Midlands). Some words used by dialect speakers were perfectly good standard speech hundreds of years ago, and the grammatical constructions are not always slovenly talk, but retain old methods of speaking which all our ancestors used. Dialects differ from town to town within the area, which further troubles the stranger.

The use of archaic words is interesting. Walter White, the London visitor of 1860, commented on the Birmingham crowds:

> Listen to the talk as you go among the throng, and you will hear to have been worried expressed by "I was so put about", ... "Well, how are yow" and "Well, good-night" are phrases in the prefix "Well" betrays a man of Birmingham wherever you meet him. "We had used" pronounced "ajuiced" and "You had ought" which spoken is "adaught" are also characteristic. "Yow adaught to bring a bigger basket, d'yow mean us to be clemm'd", says a broad shouldered artisan to his wife, doubtful of his supplies lasting till Monday morning; and signs of awkwardness will make him add "Yow'll carry it gainer this way". Of an unhandy housemaid you may hear it said "That wench ain't at all gain at her work". The master is always spoken of as "the gaffer" ...

Almost all the words White heard – "put-about", "ad-used", "ad-aught", "clemmed", "gain", "wench" and "gaffer" – are all regularly in use today,

particularly in the older parts of the Black Country or on housing estates where the majority of the population came from the same place. Some mothers, of course, as well as some schoolteachers, are much against what they call "slang", but still the words persist.

For example, there is that deadly term of abuse, "saft'. In standard English this is pronounced "soft", but it hasn't at all the same ring about it, and one cannot imagine children elsewhere dismissing some theory of their friends with a final "you're soft" with half such an effect as the Black Country child, junior or secondary, who demolishes his companion with "yo'm saft, mate". Most words which in standard English are pronounced with an "o" become "a" in the Black Country; and this is occasionally more logical than standard English, as for example when "wasp" is made to rhyme with "clasp".

Not so very long ago the negative "not" was unused in the Black Country, and there is still great reluctance to bring it service. In the nineteenth century "have not" was "hanna" (as it still is in rural Shropshire), while "is not'; was "inna" and "did not" was "didna". The letter n has now disappeared from the middle, leaving "a-a", "i-a" and "di-a", and these in turn are becoming merged into one sound. But there is still little sign of the missing "not". Instead of saying "a bus hasn't gone up yet" a Black Country speaker will go to great lengths to avoid the "not" by declaring "there a-a ne'er (never) a bus gone up yet".

Another odd survival is the use of the second person singular form in "thee" "thy" "thine" with the corresponding verb ending. A traditional Black Country tongue twister, tried cheekily on all foreigners, is "Thee cos'n cuss like thee couldst cuss, cost?" which means of course "You can't curse like you could curse, can you?" Most personal pronouns in the dialect behave in unorthodox ways; the most obvious is probably "er" used in the nominative case instead of "she", which harks back accurately to its Anglo-Saxon ancestor.

Some Black Country turns of phrase are more poetic than standard English too; the speech is less flat. Try singing out of tune, and it will be said that you "sound like a glede under a door". A glede is a cinder dropped from the fire, and the phrase refers to the horrible squeak it gives out if it gets wedged under a door, setting the teeth on edge. It might be said of someone: "Ar; some men bin like Bils'n coalmines: theer's good stuff in'em if yo could on'y get 'em dry but they'm allus soaked." If you don't fill the teacup with tea you may be told, "Looks as though the trams an gone by", even though the last tram rattled the tea out of the teacups many years ago. And be careful your explanations are clear and to the point; don't go "all round the Wrekin" or make your tale "as long as Livery Street". As for the person who's a thorough nuisance, his worst fate will be to be

64. Walsall
Metropolitan
Borough celebrates
Darlaston

sent to the ends of the earth: "Go to Brierley Hill" or "Go to Smerrick" (Smethwick).

The tenacity of the old ways of speech reflects one side of the coin of modern Black Country life. Municipal reorganization and expansion in the fields of industry and education may typify the other side of the coin. Under the West Midlands Review Order a great attempt was made to end local government chaos on April 1st 1966, and though some people have since maintained that the choice of date was particularly appropriate, the streamlining of municipal processes did bring advantages in some directions.

Five new county boroughs were constituted, four of which were based on already existing county boroughs. Wolverhampton received back Tettenhall, Bilston and Wednesfield, all of which had been associated with the town a thousand years before. Dudley took in Brierley Hill and Sedgley, where many Dudley commuters lived. Walsall acquired Willenhall and Darlaston, both of which had previously divided allegiance between Walsall and Wolverhampton. West Bromwich finally conquered neighbouring Wednesbury and also took over Tipton, the town legendary for its canals and hump-backed bridges. Coseley was partitioned between Dudley and Wolverhampton; it had originally been part of Sedgley parish, and had led rather a divided life for many years.

The fifth county borough was Warley, an amalgamation between Smethwick, Oldbury and Rowley Regis, with its constituent towns of Blackheath, Cradley Heath, Old Hill and Tividale. There are obvious difficulties in welding together such diverse places with such poor transport facilities, and geographical factors which have always divided the Black Country. It was decided by higher authority that the attempt was worth making. The name chosen by competition was that of a Domesday manor originally part of Oldbury, the site of fine beechwoods and a rolling golf course. In 1974, a further amalgamation took place, the chief result of which was the creation of 'Metropolitan Boroughs', including Sandwell, a union of West Bromwich and Warley. The West Midlands County was created, linking the Black Country authorities with Birmingham, Solihull and Coventry.

The town centres of Wolverhampton and Dudley expanded quickly after the 1939-45 war. A grand redevelopment of Wolverhampton was connected with the town's inner ring road scheme. In developing the ring road the environment of St John's church was carefully preserved, and traffic flows were much improved. Dudley has developed precincts at the back of the market place with plenty of car parks within easy reach of the shopping area. Walsall and West Bromwich also boast areas for mass-shopping.

65. Guy Motors of Wolverhampton

Of the smaller towns, Halesowen has also rebuilt part of the town centre, carefully preserving the parish church and half-timbered buildings near it; Stourbridge, which attracts custom from the country areas lying to the west, has produced an inner ring road scheme and retains high quality shopping. The character of some villages, such as Great Bridge, has been changed by the erection of new shops, but many villages look the same as they have been for years.

Large private housing estates have been built since the war, for example at Gornal Wood, Lawnswood, Wall Heath and Wombourne. New schools for these areas have followed, and the rebuilding of many old schools has provided excellent educational facilities for local children. The designation of Wolverhampton Polytechnic, later University, gave the West Midlands a higher educational establishment of which to be proud, while the opening of new comprehensive schools, for example at Tividale, Highfields (Penn), Dartmouth High (West Bromwich) and Coseley, showed the West Midland authorities keen to try this form of secondary education.

During the century Black Country industry has gradually come to be dominated by the great industrial combines. Nevertheless, there are still many small and medium sized factories in all the boroughs. Among the products of Black Country works today or recently are tubes, screws, nuts and bolts, chemicals, heavy castings, boilers, metal fittings of every kind, mineral products like tarmac, as well as the old specialist products like chains, locks, springs, scales, anchors, glass and others. An important factor has been immigration from former Commonwealth countries of people willing to undertake jobs refused by the indigenous population. Corner shops are often run by descendants of immigrants from South Asia, who have built many religious buildings to serve them. The West Midlands has acquired a taste for balti cooking, and from the African-Caribbean community, reggae music.

In various ways the Black Country faces major dilemmas in the early twenty-first century. How, for example, can tradition and modernity be made to harmonize? The Black Country Society, a civic society in which all types of people participate, has the answering of this question as one of its aims. Since the Black Country reached the height of its prosperity in the nineteenth century, many of its most remarkable monuments date from that age; yet it was not an age when artistic taste was high. Historians and artists will agree that a building such as Wednesbury church must be preserved, but what about canal locks and gasholders? Can we possibly preserve any rows of nineteenth-century miners' cottages, tilted slightly as the result of subsidence? Undoubtedly it would be difficult. On the other hand, these drunken houses have been such a feature of the landscape in the past that if every single one is raised to the ground one wonders whether the Black Country will be dead.

**WAR-CRY OF THE
MIDLAND CONSERVATIONIST**

A list of items for conservation
Should surely include West Bromwich station,
With the cooling towers up at Ocker Hill
And the broken wreckage of Stambermill.

You know these roads with the bridges shut?
Well, they're actually filling in the cut,
And draining out all the dirty water:
Now, it ai' right, mate, they didn't oughter.

It's glorious conservation year:
Now an end's been put to my greatest fear,
That progress would threaten a dreadful loss:
The vinegar works at Aston Cross.

John Betjeman went to see Round Oak
And took off a valuable bottle of smoke,
While a great big chunk of our Bilston sky
Has been sold to East Grinstead W.I.

There's a grimy public at Princes End
Where they're driving the landlord round the bend
Now they know all around for miles and miles
That the floor is encaustic Victorian tiles.

Are you coming with us down Cradley Heath?
These regulations still need some teeth,
And we're going to lie in the road all day
To stop them taking Christ Church away.

Then there's nature as well to conserve of course
So we're keeping a rag and bone man's horse,
And we're all for protecting the common slug,
The woodlouse, hair nit and short-tailed bug.

Yes, we're fighting to keep our heritage
Though the tractors roar and bulldozers rage.
And when we've shown that we really care—
I'll race you to Weston-super-Mare!

Left: 66. A poem for the 1970s

Below: 67. Dartmouth Square in the early twenty-first century

68. Midland Metro at Bilston's former GWR station

Part of the answer to this was the founding of the Black Country Living Museum on land at Dudley, supported by the four Metropolitan Boroughs. This marvellous enterprise draws enthusiastic crowds to re-live the recent past, riding the trams or trolley-buses, watching the chainmaker, descending the coal mine, singing in the chapel moved from Darby End. Here explanations are given to school children from the Black Country and its fringes, as well as from further afield, of the life of our recent ancestors, their toil and hardships as well as their hard-won respectability and determination to triumph over dirt and poverty.

And even if the councils do flatten the "skew-wifted" houses and lay antiseptic grass plots and tarmac car parks everywhere, it won't be long before a new crop of Black Country children rush out of the smart new houses and colonize the grass for a football pitch ("Yo can be th'Albion, we'm the Wolves!") while their sisters mark out hopscotch squares on the new-laid slabs. Among the children will be little Dudleys, Whorwoods, Turtons, Parkeses, Foleys, Woodhouses and Attwoods; and by the continuity of their surnames and their way of talking, if by nothing else, they will show the continuity of the Black Country.

FURTHER READING

All writers on the Black Country are indebted to the work of F. W. Hackwood, who devoted his life to local history at the turn of the century, producing volumes on Darlaston, Handsworth, Oldbury, Sedgley, Smethwick, Tipton, Wednesbury, West Bromwich and Willenhall among other places. Several of these have recently been reprinted. Copies can be found in libraries and are well worth reading.

A series called 'Britain in Old Photographs' contains many splendid volumes.

Local authorities have subsidised various books and Staffordshire Parish Register Society publishes annual volumes, many of which have covered Black Country parishes.

The Blackcountryman magazine, published by The Black Country Society from 1968 onwards, contains useful articles on many aspects of Black Country history. Files of the *Black Country Bugle*, with its annual Christmas issue, are entertaining and valuable.

Also available from Amberley Publishing

Winson Green to Brookfields Through Time
by Ted Rudge

Price: £12.99
ISBN: 978-1-84868-132-3

Available from all good bookshops or from our website
www.amberleybooks.com

Also available from Amberley Publishing

A History of Bridgnorth
by Clive Gwilt

Price: £12.99
ISBN: 978-1-84868-393-8

Available from all good bookshops or from our website
www.amberleybooks.com